what not to wear

Trinny Woodall & Susannah Constantine

what not to wear

Trinny Woodall & Susannah Constantine

Photography by Robin Matthews

WEIDENFELD & NICOLSON

To Sten and Johnnie with our Love always.

First published in the United Kingdom in 2002 by Weidenfeld & Nicolson

Text copyright © Susannah Constantine and Trinny Woodall, 2002
Design and layout copyright © Weidenfeld & Nicolson, 2002

By arrangement with the BBC
The BBC logo is a trademark of the British Broadcasting Corporation and is
used under licence.
BBC logo © BBC 1996

A CIP catalogue record for this book is available from the British Library
ISBN 0 297 84331 1

Design director David Rowley
Editorial director Susan Haynes
Designed by Kate Stephens
Edited by Jessica Cowie
Photography by Robin Matthews

Typeset in Century Schoolbook and Arial
Printed and bound in Italy

Weidenfeld & Nicolson
Wellington House
125 Strand
London
WC2R 0BB

what not to wear

contents

Looking stylish is as much about knowing **what not to wear** as it is about knowing what suits you. It's about **being honest** and coming to terms with the fact that **some parts of your body aren't great** and understanding that certain clothing only serves to exacerbate these problem areas. So many of us trundle through life not making the most of ourselves because **we are lacking in self-confidence**, convinced that clothes don't matter or have no idea where to begin. But the more you know about your body, the easier it is to look great.

Unfortunately, for a lot of us there are many hurdles to jump before we reach that stage and **we incorrectly believe the notion of becoming stylish is a feat way beyond our grasp**. We roll our inexperience in comforting excuses – there's the kids, the overdraft, no time, nor inclination. Clothes are immaterial, because you can rely on your fabulous personality and your partner is blind to you looking like a tramp, because he loves you just the way you are. At the end of the day this is bollocks. We believe there isn't a single one of you who doesn't want to **improve the way you look**. Even if you assume you have the style of a goddess, you'd probably like to trade in your tits for a pair that defy gravity, and if you've got the tits, you'd no doubt consider your butt too large to even contemplate displaying its cheeks in a tight pair of trousers.

You believe diet, money and surgery are the answers but you're too greedy to do the first, will never make the second and therefore can't pay for the third. If you can, however, accomplish all these, fantastic, but then of course your next apology is supposing you have to be fashionable to be stylish and if you are too old, too young, too thin, fat, tall or short it's not possible. **But looking stylish is not about following fashion**, losing weight, being rich or succumbing to the knife. **It's about dressing to show off what you love and hiding what you loathe about your body**. Once you really understand **what not to wear** the path to chic-dom becomes a piece of cake.

American fashion guru Diana Vreeland said 'Elegance is innate…it has nothing to do with being well dressed.' **The myth that you are born with style is incorrect** and an unfair supposition to bandy about. In our opinion it is actually codswallop. Would she be saying that about a born 'elegantsia' dressed in an over-sized fleece and leggings so tight they showed her cellulite? Would she say it to toothpick-thin fashion icon (and some say Ms Vreeland's successor) Anna Wintour if she was wearing a plunging neckline that exposed her skeletal chest and a gathered skirt that swamped her oddly thin frame? We don't think so. You might have the grace of a prima ballerina, but if you

have fat, pitted thighs no mini-skirt, however gorgeous, is going to flatter them. **Style isn't something you are born with, but something anyone of you can learn**.

We are prime examples of this. Should anyone think we do indeed have a modicum of style or lean towards possessing a good figure, they need to know that the former has taken years to accomplish and the latter is a complete deception. Our figures are tall and, in Trinny's case, thin, but any semblance of 'nice bod' **boils down to clever disguise**. Trinny has always been passionate about clothes, devouring glossy mags from a tender age, but it took a good two decades to rid her of her theatrical passion for filching the look of the latest pop group. In the Eighties, she owed a great deal to Spandau Ballet for her girl-meets-gay-boy, pin-stripe suiting, whilst it was Bucks Fizz that paved the way for a fluffed and frosted barnet that was often capped by a jaunty trilby. Big earrings went with the big hair, both of which were set off by an orange skin tone courtesy of No.7 fake tan and pearly pink lipstick. This sounds vile and indeed it was, but her figure was always spoken of in the revered tones reserved for the extra-ordinary. The **truth as you will see is very different**. Trinny is thin, but thin with very short legs, no tits and a disproportionately large and succulent bum. But because she has **learnt**

to disguise these defects all the onlooker sees are endlessly long limbs and a sculpted arse, and because she dresses so well for her shape you don't even notice she's as flat as a prairie.

First impressions of Susannah may not be as favourable as Trinny, but some could think **oooh...sexy, curvy figure**. What a joke. Behind the neat waisted jackets and three-quarter-length sleeves lies a body that is out of control and, after two kids, stretched beyond redemption. Her stomach needs stapling, her underarms hang as dramatically as the Gardens of Babylon and her tits are way too large for human handling. Nevertheless, she has been **educated well in the art of camouflage**, but her style education didn't begin till she met Trinny, in spite of having worked with some of the world's leading designers. Susannah was schizophrenic in her lack of dress sense. It was vestal virgin meets King's Cross crack-crazed hooker. On the one hand she embraced all that was ghastly about Sloane Ranger dressing, whilst allowing her alter ego to indulge in Marabou-trimmed gloves, laddered tights and unfeasibly teeny skirts. Someone once told her she had good legs, so one was lucky to ever catch her out of a skirt. The hair was extremely long with a swamping fringe aboard a short, fat neck that was forever throttled by a pearl choker. There was no discretion in her clothing but she

got away with much of it **because the clothes suited her shape**.

Since those years of darkness we have worked in and seen the fashion industry from all angles. We regard 'fashion' as a pretty frivolous affair, and the higher it gets, the more absurd it becomes. Yet when it comes to clothes it turns into something deadly serious. **When we shop we want our purchases to change our lives**. When we get dressed we want the Good Fairy to turn us into Elle Macpherson. Sadly, for most of us the Good Fairy is a manifestation born from nubile models posing from the gleaming pages of fashion magazines. These present unobtainable images that none of us mortals can even aspire to. The result of trying to look like them is one of immense frustration. You attempt to do it, but are often disappointed by the outcome. The frustration becomes all encompassing.

Having worked with an array of women for our BBC show 'What Not to Wear' we have witnessed the female species' insecurity and frustration first hand. Some of them thought clothes were ridiculous, others were sure they were beyond help. Many of the women could only see what they hated about their bodies. Once we pointed out that they had fabulous ankles, great boobs or a beautifully honed back **they felt encouraged**

that becoming stylish was possible. Many people may think our tactics harsh and unforgiving, but we are proud of the results. Every lady on our show has turned into **a gleaming example of confidence**. Men think women are mad for getting so uptight about clothes. But we know that at the end of the day **the way we look can influence so much in our lives**. Looking sexy makes us feel sexy. Looking professional helps us get that job. **First, however, you need to get the shapes right.**

We hope that every woman who reads this book feels we are there bullying her into submission. Pass it on to your girlfriends, but keep it hidden from the boys and girls you don't like. The men don't need to know how **you have suddenly become a siren**. The competitive workmates can be kept in the dark as to why you look thinner, sleeker and more sophisticated. **This is your secret weapon, and remember, it's not so much about the tips you've been given, but more about the mistakes you have stopped making**. As long as you stick to the rules, you can forget what's in fashion. If, however, you have a passion for what's in fashion then **simply adapt this season's hot trend to your individual shape.**

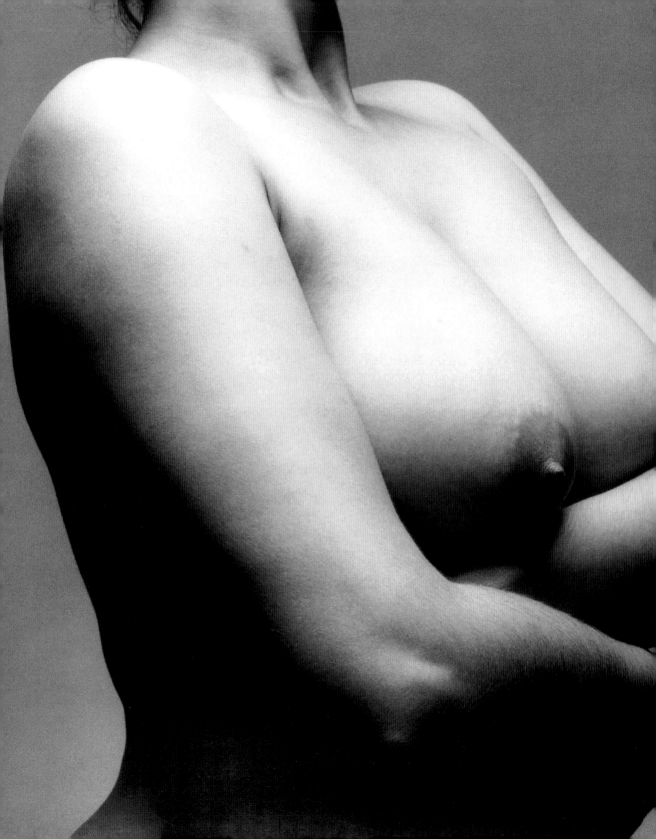

People may look at you and think you have an amazing pair of tits – **so what's the problem?** Well, for a start, Susannah knows, and Trinny can imagine, that buying dresses, suits and coats to fit both the top and bottom halves of your body requires a degree in anatomy. And whilst we're all in favour of a girl **making the most of her natural assets**, she needs to be careful not to look top-heavy or tarty. It is lovely having men magnets when you're out on the town, but there are times when you want to be appreciated for your brain power. This requires **decorous dressing** and the implementation of **surreptitious tricks** to tone things down. The primary tool, and one that will become indispensable, is a well-fitting bra. Invest what ever it takes to find the best one for you. Hoick them up high and push them forward with under-wires and strong straps. Armed with **the right bra**, you are in control of your jugs rather than the other way around. It's much more exciting having tits that can be exhibited as and when the occasion requires.

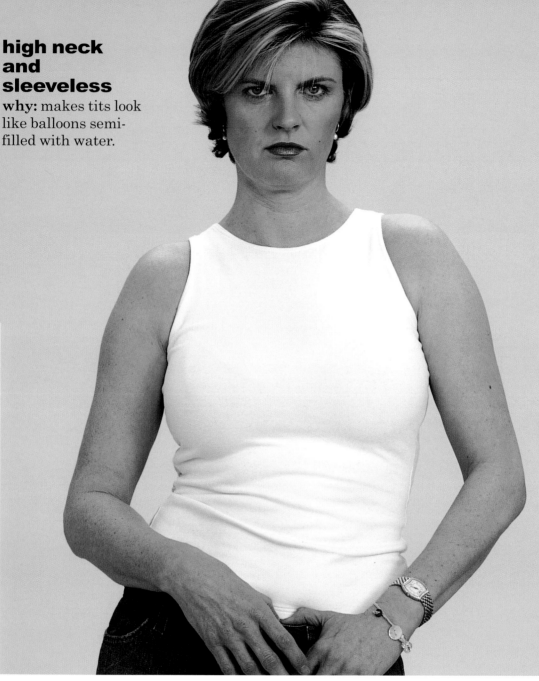

**high neck
and
sleeveless**

why: makes tits look
like balloons semi-
filled with water.

worst t-shirt

<u>or</u>
high round-neck t-shirts
why: moulds boobs into one big lump.

wide-open neckline

why: a low, wide neckline breaks up the chest and prevents your tits looking like they are an extension of your chin.

alternative
V-neck sleeveless t-shirts

why: the V breaks up the expanse of your chest (no sleeves are for that rare bird blessed with toned arms and a pert chest).

1

unfitted, sleeveless shell top

why: udders take on a lumpy quality like badly made custard.

or

round-neck vests

why: large breasts invariably have big arms to carry them and these should remain hidden at all times.

tight around the waist and loosening on breasts

why: because the fabric is looser on the chest it gives the illusion of not having too much to fill it. Your waist will also look tiny by comparison.

corset shape with sleeves

why: accentuates breasts without being vulgar.

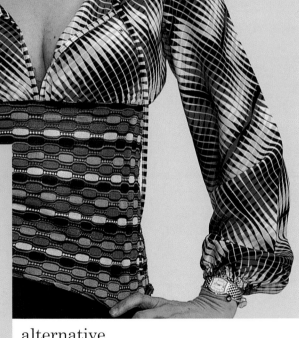

alternative
wrap tops
why: pull tits forward and spotlight waist.

boxy, short-waisted jacket

why: makes you look square, shapeless and top-heavy.

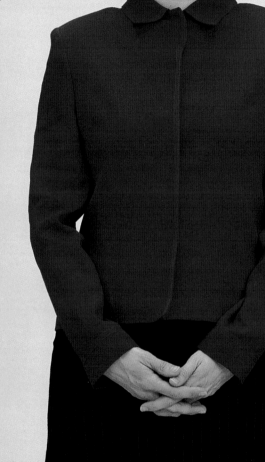

<u>or</u>

princess collar

why: anything buttoned at the neck will give you larger boobs than you need.

very fitted, deep V, with hem cut to hip and a small lapel

why: short length lengthens legs and deep V divides the tits.

best jacket

halterneck

why: hard to wear a bra, which means tits creep out at the sides.

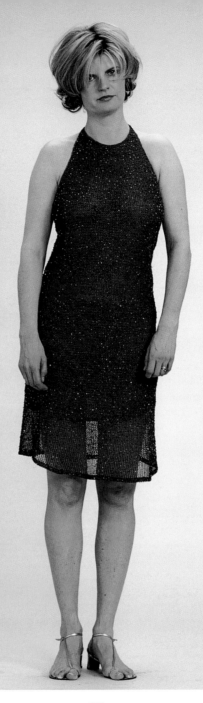

<u>or</u>
spaghetti-strap slip

why: thinness of straps enhances size of shoulders and tits.

wrap dress

why: pulls in the waist and divides and separates the bust

sweetheart neckline, empire line and three-quarter-length sleeves

why: makes the neck long and elegant, rather than bunching boobs up to the chin.

alternative
cocktail dress with low draw-string neckline

why: hides tummy; gathered fabric helps to dwarf size of chest and prevents tit-clinging.

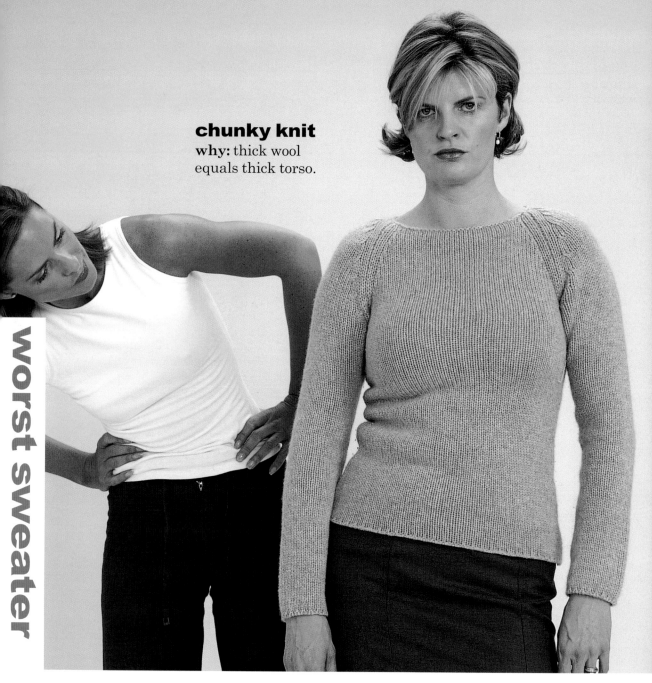

chunky knit

why: thick wool equals thick torso.

or
polo necks

why: tits take on a new role as third chin.

alternative
round-neck cardigan
undone to the top of your bra

why: shows off that stunning cleavage – with the added bonus of being able to do it up when cold or feeling over-exposed.

alternative
deep V neck in a fine knit

why: fine cashmere will keep you warm and looking svelte, whilst the deep V will divide the tits, showing your God-given two, as opposed to a deformed one.

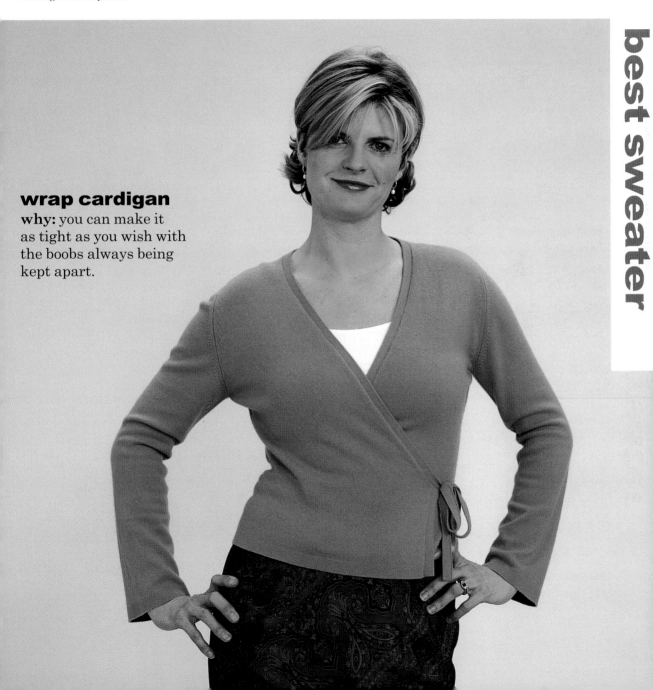

wrap cardigan

why: you can make it as tight as you wish with the boobs always being kept apart.

best sweater

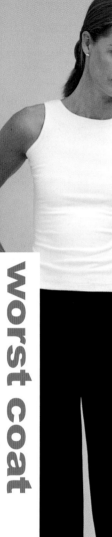

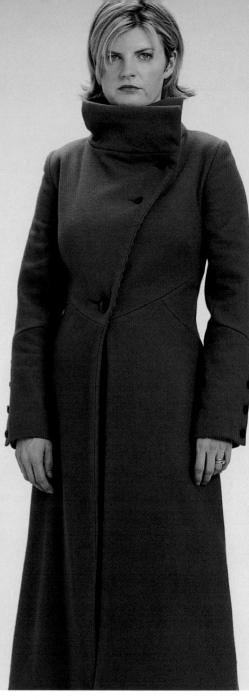

funnel neck

why: any garment that is done up to the neck will always distort the breasts.

<u>or</u>
double-breasted anything
why: two rows of buttons broaden the chest – not good for creating a body of perfect proportions.

<u>and</u>
belted trench
why: creates an uncalled-for billowing around an already breasty area.

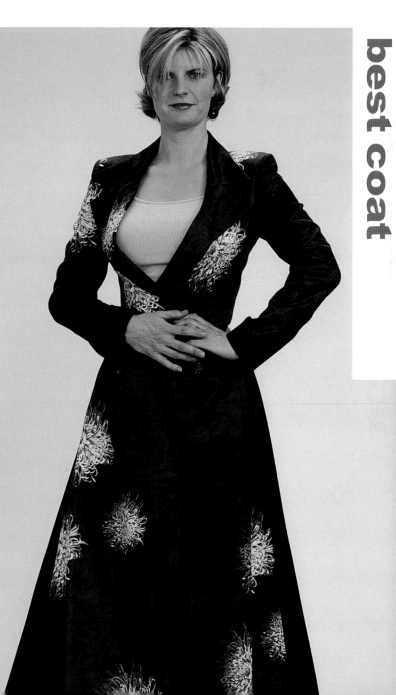

tight waist with narrow lapel and full skirt

why: the depth of neckline breaks up the expanse of swollen flesh.

	no guilt	slight guilt	guilt for days
t-shirt	M&S Knickerbox	Jorando Velvet	Chloe Mimi Boutique Studd
sweater	Oasis Zara Top Shop	Whistles Joseph French Connection Vanessa Bruno	TSE cashmere Martin Kidman Rachel Riley
top	Top Shop Zara Hennes	Karen Millen FrostFrench Mint Vanessa Bruno Uth	Missoni Tracy Feith Rozae Nichols Miu Miu Anna Molinari
coat	Top Shop Zara Hennes	Marc by Marc Jacobs See by Chloe Joseph Earl Jean	Marc Jacobs Dries Van Noten Dolce & Gabbana
dress	Hennes Zara	Betsey Johnson Ghost Joseph	Alberta Ferretti Chloe
jacket	Warehouse Top Shop Gharani Strok for Debenhams	Paul&Joe Mint Karen Millen Whistles	Gharani Strok Dolce & Gabbana Sybilla Sybil Stanislaus Anna Molinari Diane Von Furstenberg

golden rules for for big tits

Never wear high round necks.

Never wear cable knit sweaters.

Nehru jackets are for men only.

Don't ever leave the house without doing the bra test. If you can see the contours of padding or lace, take it off.

Avoid ribbed polo necks – they make your tits look like they grow from your neck.

Chuck out the clothes that don't suit you – even if you think of them as old friends.

Never put on underwear that's darker than the clothes you're wearing.

golden rules

Subtle is sexy – vulgar is not

If you are the owner of **a chest bereft of tits**, you have no doubt longed for boobs, thought about surgery and tried all breast-enhancing trickery to boost what isn't there. The ironic thing is, many big-titted women look at the daintily endowed with envy. Susannah longs to be able to wear clothes that Trinny can. Loads of **clothes look better** worn by flat-chested women. They hang better and this must surely be a compensating factor for worrying about not being sexy. You **don't need tits to be alluring** and at least you have the choice of a breast day or a non-breast day. You can boost your sexiness with padded bras and silicone extras. We know it's hard sometimes for the unattached, because young men especially need an eyeful of tit before they even talk to you. Maybe this isn't such a bad thing, as turn this notion on its head and **your dainty boobs** are actually a filter for all the jerks out there. **An added bonus** is that there isn't a single coat or jacket you won't look fab in.

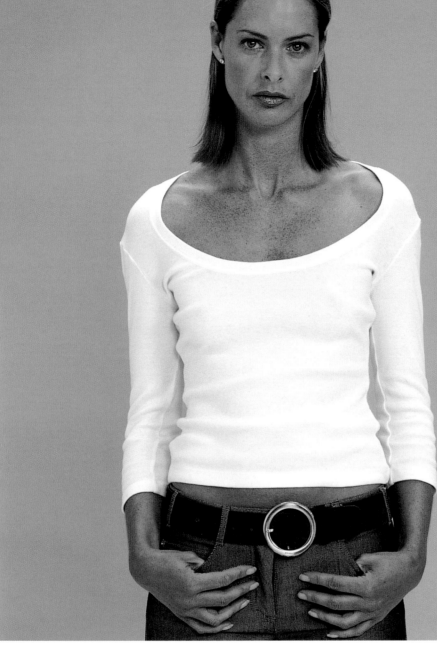

low scoop neck

why: accentuates a bony chest which looks more like a deflated balloon than a swelling cleavage.

<u>or</u>

deep V neck with three-quarter-length sleeves

why: the V acts as an arrow to the disappointment of not having anything to fill it. Three-quarter-length sleeves show the thinnest part of the wrist, making the overall effect way too skeletal.

high neck vest with cut-away sleeves

why: attention is drawn to the arms, which are invariably slim and on tit widows.

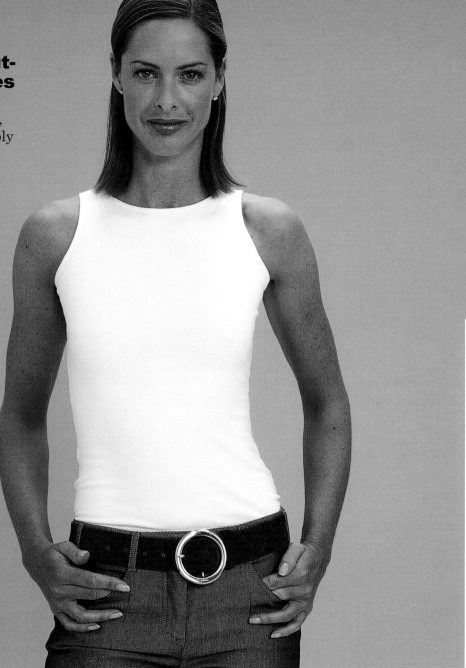

alternative
slash neck with capped sleeves

why: the slash broadens shoulders and the capped sleeves create coat hanger angles normally reserved for models.

corset

why: designed to enhance the chest, if there is nothing to bolster then the whole thing becomes redundant.

<u>or</u>
boob tube
why: on a girl with breasts it looks cool, on a girl with none it becomes a bandage with nothing to keep it in place.

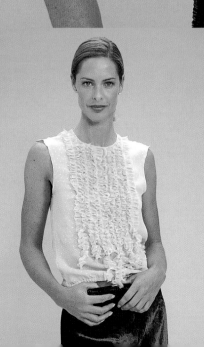

halterneck

why: yes, there are bras designed to wear with these, but little tits work in tandem with the angular cut of this top. They also show off a shoulder which is a sexy substitute to a cleavage.

alternative
sleeveless top with detailed front panel

why: frills and froth cover the chest and make up for what is not there.

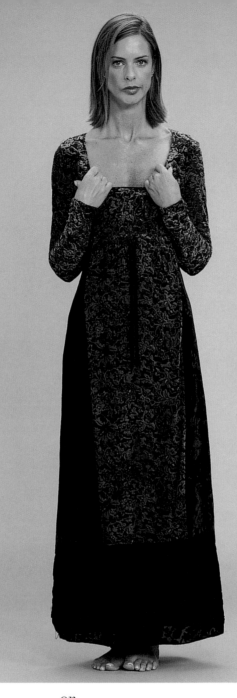

empire line

why: hangs like a habit on a nun from a very strict order. No need for a chastity belt here.

<u>or</u>

**skintight and stretchy
with spaghetti straps**

why: there is nothing worse than a condom that isn't filled properly. Skintight on a skinny top half isn't sexy, it's a disappointment.

high neck and a little see-through

why: tiny tits can get away with subtle nipple display. As long as it's not too overt it can be truly sexy.

plunging neckline down to navel

why: you can't do this look if you require artificial uplift, but it's fabulously seductive if you don't.

best dress

alternative
backless

why: a beautiful back is just as desirable as a heaving chest.

why: the gossamer fabric clings to the skin, creating a wet t-shirt effect, clutching raisins as opposed to peaches.

worst sweater

chunky polo neck

why: on a woman blessed with a flat chest these look immeasurably elegant — the roll neck looks like a roll neck, as opposed to an extra chin on a woman with boobs.

<u>alternative</u>
fitted long sleeves with round neck
why: the simple lines of this shape are not ruined by the bulk of large bosoms.

	no guilt	slight guilt	guilt for days
t-shirt	Knickerbox Top Shop M&S	Michael Stone (from Whistles) Juicy Couture French Connection	Chloe Marni Gucci
top	Top Shop Petit Bateau M&S Tesco	Jigsaw Mint Vanessa Bruno DKNY	Alice Temperley Chloe Dries Van Noten Prada Marni Pucci
dress	Zara Top Shop	Joseph Ronit Zilkha Nicole Farhi Giant	Chloe Marni Alice Temperley
sweater	Top Shop Oasis Zara	Brora Joseph Ann-Louise Roswald John Smedley	Marni Prada Gucci Etro

golden rules for no tits

Plunging necklines are only for perfect décolleté undamaged by the sun or age.

Corsets are for those with tits.

Flat chests need high necklines.

Chicken fillets for breast enhancement must always be secured with a bra or they will fall in the soup at dinner.

Backs are sexy alternatives, so keep them shiny and exfoliated.

Chuck out the clothes that don't suit you – even if you think of them as old friends.

If you're wearing a V-neck jumper, always wear a round-necked t-shirt underneath.

You might think a scoop neckline gives the appearance of tits – but all it does is show off an empty space.

golden rules

Remember, you may not have been born with style but you can create it

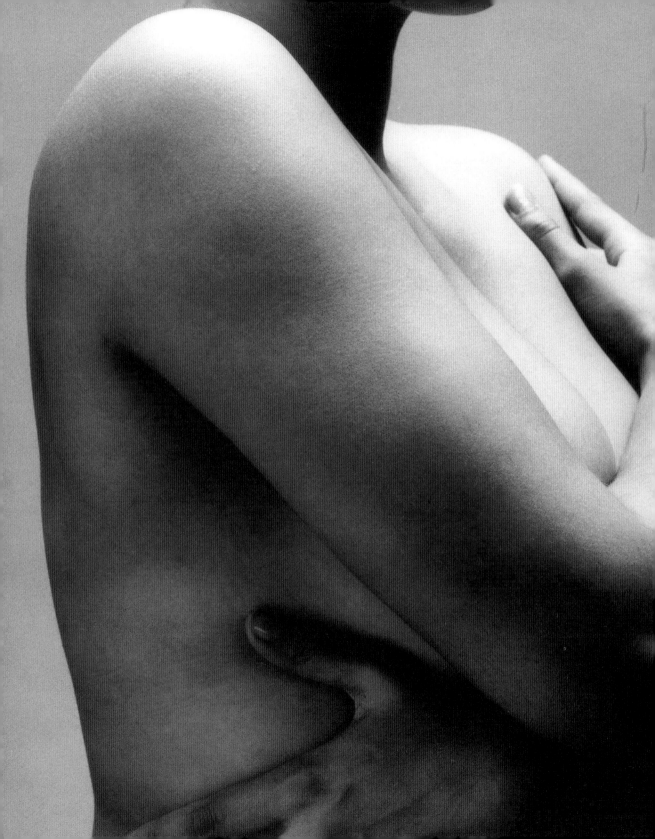

Big arms are the bane of this nation, not that the nation seems to give a damn. Women unashamedly baring huge arms **that need to be covered** continually confront us. We don't, however, lay the blame at their feet. It's the manufacturers who should be shot for not knowing their market. They are hell-bent on mass-producing tops and dresses with no sleeves and these in turn are the ones photographed for the magazines. Susannah, whose upper arms could feed a family of six, finds the **lack of sleeves depressing**. Flicking through the glossies each month, her heart breaks. What the hell is she, the owner of plucked chicken wings, **supposed to wear in the summer?** What in God's name should one do for an evening frock if the arms need covering? Go to the ball looking like a dowager duchess or just not bother. If there were more sleeves around the problem of naked jiggling flesh would cease to exist and women like Susannah would **no longer feel the frustration of having to make do** with t-shirts, cardigans and dowdy dresses.

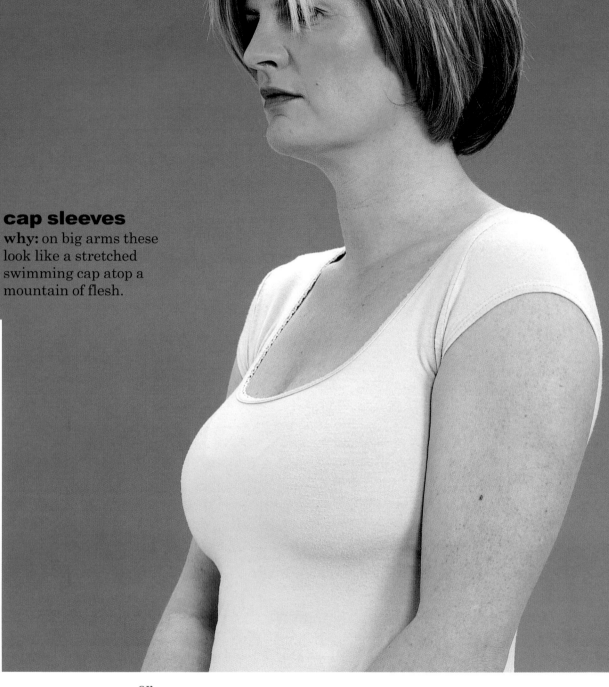

cap sleeves

why: on big arms these look like a stretched swimming cap atop a mountain of flesh.

or
sleeveless vest

why: do you really want the world to see your most hideous physical defect? Hide the buggers, for goodness sake.

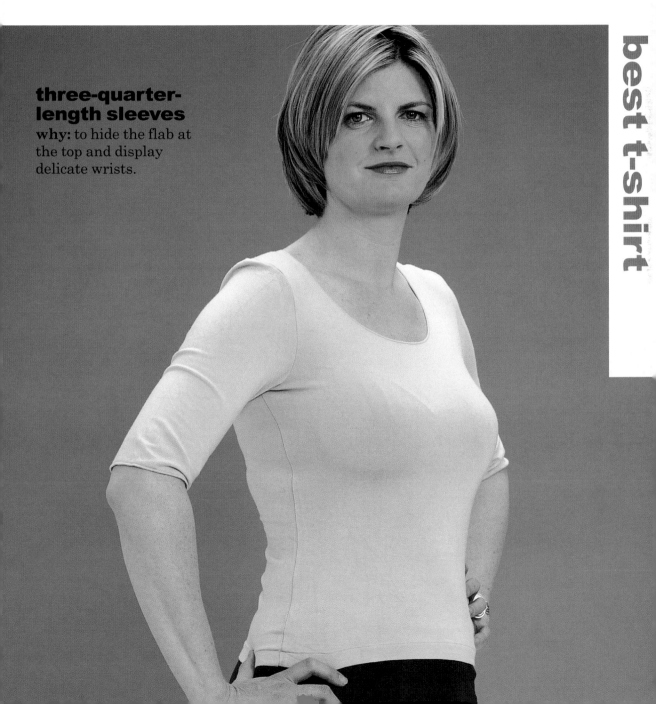

alternative
long-sleeve t-shirts
why: the sleeves obviously hide the sins; just be sure they aren't too tight and resemble vacuum-packed frankfurters.

three-quarter-length sleeves
why: to hide the flab at the top and display delicate wrists.

best t-shirt

puff sleeves

why: elastic sleeves will create two very fat sausages, as opposed to one.

or

halterneck

why: the narrowness of the top at the neck will only spotlight the comparative hugeness of the arms.

floating cuffs

why: cuffs in a flimsy fabric add a certain delicacy to beefy arms whilst hiding the heftier truth.

alternative
puff at shoulder seam

why: a roomier armhole fits a fatter arm and the blouson effect doesn't squeeze, which gives the impression of something altogether more elegant being inside.

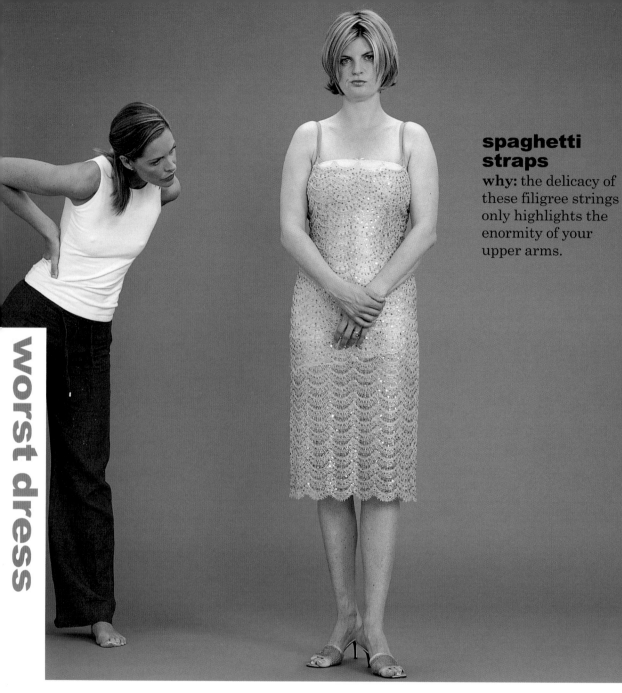

spaghetti straps

why: the delicacy of these filigree strings only highlights the enormity of your upper arms.

<u>or</u>

sleeveless shift dress

why: people will wonder how that gargantuan mass of flesh managed to squeeze through the armhole.

fluted sleeves – the more exaggerated the better

why: like a bootleg trouser on a heavy thigh, the breadth of the cuff balances out thick upper arms.

alternative
sleeves

why: on anything sleeves elongate the forearms, making the entire garment more elegant and willowy.

alternative
sleeved dress in a small pattern

why: the busyness of the pattern detracts from the arm.

big bangle

why: by rights this should make the arm look thinner. As you see it doesn't because it's hiding the thinnest part... your wrist.

delicate bracelet

why: shows off and prettily decorates the finest part of your arm.

	no guilt	slight guilt	guilt for days
t-shirt	Jigsaw	Velvet	Fake
	Petit Bateau		Studd
	Gap underwear		
	Zara		
top	Warehouse	Mint	Missoni
	Oasis	Sara Berman	Fake
	Zara	Karen Millen	Chloe
		Dosa	
dress	Warehouse	Mint	Diane Von Furstenberg
	Oasis	Karen Millen	Dolce & Gabbana
	Zara	Dosa	Giorgio Armani
			Sybil Stanislaus

golden rules for big arms

Fat arms must always wear sleeves.

Capped sleeves are an absolute no – they strangle big arms.

Small prints cover a multitude of flabby flesh.

Be ruthless – chuck out the clothes that don't suit you and treat yourself to some new ones that do.

golden rules

Don't be scared of appearing different from your friends

Most big bum bearers hate their rumps. But as long as it's pert **it doesn't matter how huge it is**. There is something very sexy about a rounded rear, so rather than trying to hide it, **show it off**. Don't be frightened to wear tight skirts; a man would far rather have something meaty to cling on to. In dressing a butt, think about how a pregnant tummy looks best.

One that is shown off by **tight clothing** is much more flattering than one that is tented by swathes of fabric. Material that hangs too voluminously from the fleshiest part of a protruding butt makes your thighs and arse mould into one mass.

A bum that is disproportionately vast isn't great, so **the sly use of tricks** to deceive the eye into believing it's more in proportion is what you need.

The bummer about **fleshy buns** is that if a skirt or pair of trousers fits around the arse, it may well not fit your waist.

It might just be then that you have to resign yourself to the local seamstress who can take in the loose fabric.

high-waisted and tight

why: waistband cut high around the waist makes bum look bigger because there is more fabric.

or
front pleats

why: pleats will be pulled out by fat backside.

and
tapered trousers

why: make your ankles slim, but Jesus, does your arse look enormous above them.

side-fastening, loose-fitting trousers

why: the lower waist-band cuts the bum area in half making it in turn half the size.

alternative
wide-leg trousers

why: keep it all well balanced, as they don't so much cup the bum as hang softly away from it.

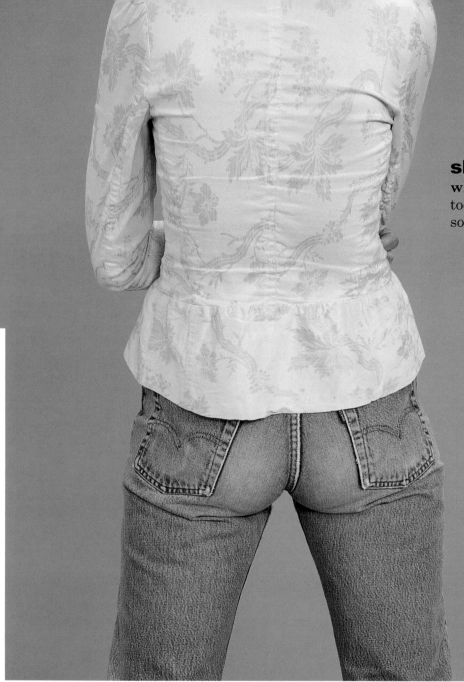

short jacket

why: simply looks
too small to cover
something so big.

<u>or</u>
**jackets ending on or above
your backside**
why: will only exaggerate its width.

<u>and</u>
long, straight coat with no definition
why: will be too tight around the bum and too loose
on the waist.

alternative

slimline jacket that ends under bum
why: covers bodily sin whilst keeping a sharp silhouette and whitewashing the truth.

best jacket

a tailored look that flares over the bum
why: hides and balances the bum, giving a feminine shape.

A-line

why: a big bum in an A-line skirt balloons the fabric out at the back, making it enormous in comparison with legs. Looks like a pregnant tummy in reverse.

or

straight skirt

why: hangs unattractively from arse making your thighs look wide and calves like little pins emerging from the Channel Tunnel.

flared

why: clasps the buns and kicks out from the back of the thighs giving an S-shaped elegance to your rounded buttocks.

a pencil skirt

why: clings in all the right places and made up in a tailored fabric has a corset effect that keeps it all together.

best skirt

4

large prints in a soft fabric

why: floaty fabric offers no help in terms of holding the flab in and a bold print will only make a mountain range out of an outsized molehill.

or
long dresses cut on the bias

why: will make your bum look like a lollipop on a stick.

and
rear-squeezing dresses

why: if it's a close fit on your bum, it won't fit anywhere else.

tailored or fitted dress (but please, no shifts)

why: gives a controlled, yet sexily displayed outline.

	no guilt	**slight guilt**	**guilt for days**
trousers	Zara	French Connection	Giorgio Armani
	Jigsaw	Laundry Industry	Alice Temperley
	Top Shop	Betty Jackson	
	Nuala by Puma		
jacket/coat	Oasis	Joseph	Alice Temperley
	Top Shop	Whistles	Chloe
	Zara	Betty Jackson	Marni
skirt	Zara	Gharani Strok	Prada
	Top Shop	French Connection	Dolce & Gabbana
		Karen Millen	Dries Van Noten
		Monsoon	
dress	Zara	Joseph	Elspeth Gibson
	Oasis	Whistles	Anna Molinari
	Warehouse		
	Top Shop		

shopping

golden rules for big bums

Never wear jackets that end at the ass.

Any panty line on the rear is revolting.

Put on the outfit you feel most confident in and work out why you like it so much. What does it cover and what does it reveal?

Hipster trousers cut your bum in half.

High-waisted trousers make your bum look HUGE.

golden rules

Friends may be rude about
your new-found style –
it's only because they are jealous

Not having a waist can **stifle a woman's femininity**. Just look at the lengths they went to in creating an almost obligatory 18-inch girth in the past. **Thickening middles** were winched in with necessary ferocity by corsets that regularly made the wearer pass out. And why? **To craft the classic female form**, which resembled an exaggerated hourglass – curvaceous and womanly in its shape, acceptable to society in its symbolism. Thankfully, we are way beyond those days of implementing strict distinctions between the sexes and now have the **freedom to be what the hell we want**. That said, it would be nice not to be mistaken for a bloke from the rear view. Corsets can do wonders for a girl's waist, but they aren't the only thing able to give what your genes chose not to.

baggy sacks

why: you may have as much form as a tower block, but that doesn't mean to say you have to enhance it with shapeless clothing.

<u>or</u>

boxy cardigans

why: square in cut, these ill-defined sins make a woman as sexy as dried vomit on the edge of a loo seat.

navel-deep Vs

why: these slice up the slab of torso, making you less a woman of substance and more a being of refined beauty.

corset tops

why: there is nothing like a bit of boning to create that elusive hourglass body.

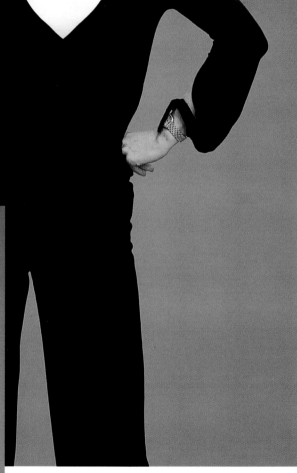

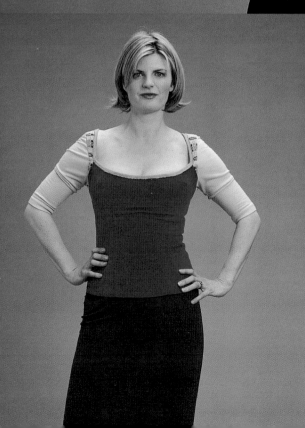

alternative
wrap tops

why: the wrapped fabric creates the illusion of curvature, particularly when the ties are bound at the side of the waist.

double-breasted

why: the two rows of straight-stitched buttons make no effort to convince the eye that there is indeed a waist under that jacket.

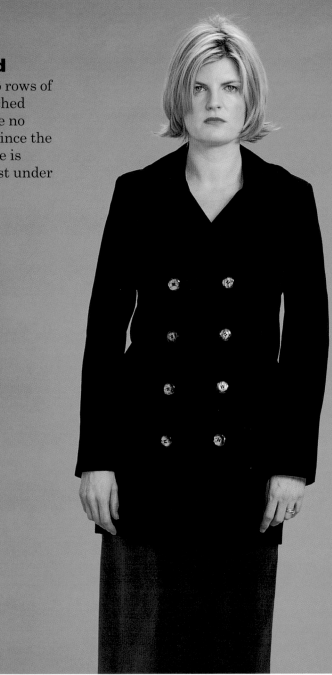

<u>or</u>
bolero jacket

why: these are so short that they leave your entire waist exposed to scrutiny and salacious comments.

alternative
short zip-front leather
why: worn with a belt slung just below, this will make the lower-waist bigger, thus minimising the waist above.

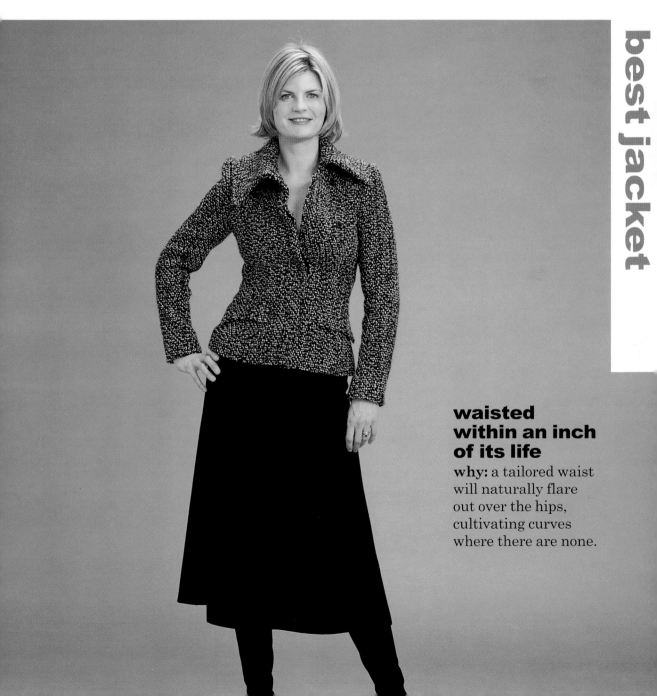

waisted within an inch of its life
why: a tailored waist will naturally flare out over the hips, cultivating curves where there are none.

the trench

why: undone, this is a pathetic excuse for a coat and will do nothing but swamp any semblance of femininity. Belted, it will draw attention to the stress the belt is under to meet around your middle.

or

straight-cut overcoat

why: if it fits your waist, it will bag over your backside.

frock coat

why: as these have a fabulous waist cut into them, don't ruin the curvaceous line by doing it up. Let the coat do the work for you.

the shift

why: think back to the Princess of Wales's worst looks and they will surely be one of those ghastly shift dresses she wore. Not blessed with a waist, she looked very mannish in this most dull of dresses, that have only ever looked good on Jackie Onassis. The reason? She was fragile to the extreme, with great legs, no tits and a very square jaw.

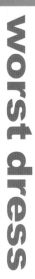

worst dress

alternative

wrap dress

why: as with a wrap top, a wrap dress
helps the art of deception.

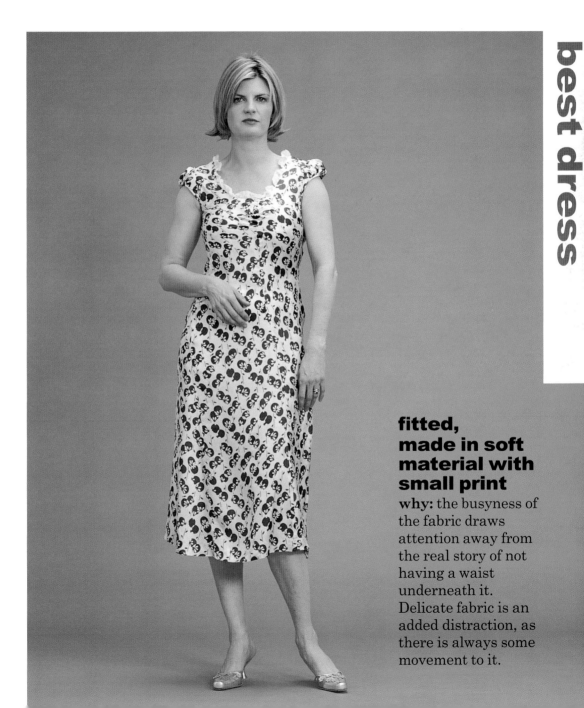

**fitted,
made in soft
material with
small print**

why: the busyness of
the fabric draws
attention away from
the real story of not
having a waist
underneath it.
Delicate fabric is an
added distraction, as
there is always some
movement to it.

	no guilt	slight guilt	guilt for days
top	Zara Top Shop	Velvet Miu Miu Karen Millen	Tracy Feith Missoni
coat	Hennes Zara Oasis	Joseph Dries Van Noten	Dolce & Gabbana Alexander McQueen Alice Temperley
jacket	Top Shop Zara Hennes	Joseph Jigsaw Karen Millen	Vivienne Westwood
dress	Warehouse Oasis	Whistles Karen Millen	Diane Von Furstenburg Vivienne Westwood Marni John Galliano

golden rules for no waist

Never wear baggy sacks.

Deep V necks clinch in the waist.

The corset has become more comfortable since the 19th century, so invest in one.

Thick belts around the hips make the waist appear smaller.

Bandage underwear is like pastry under a rolling pin – it flattens it all out.

All things double-breasted must be chucked out.

Tailored coats left undone create the appearance of a waist.

golden rules

Give your wardrobe a good workout – it's twice as satisfying as a day's shopping

If you've got or don't want perfect tits then it will be **long legs** you're after. These, like lovely breasts, are a reason to hate anyone who owns them, especially as cosmetic surgery is yet to perfect a method of **increasing the inside leg measurement**. Trinny sympathises wholly with stump owners. She's had them all her life. Rather than live with them, though, she has learnt **how to hide them**, quite brilliantly. No one would guess that lurking beneath those **long-line jackets and fully flared trousers** are pins better attached to one of Snow White's small friends. If she can **give the illusion of legs** to rival Elle Macpherson, anyone can. And like all easily solved problems, it frustrates us immensely to see women who have given in to the fact that they are Corgis rather than Lurchers.

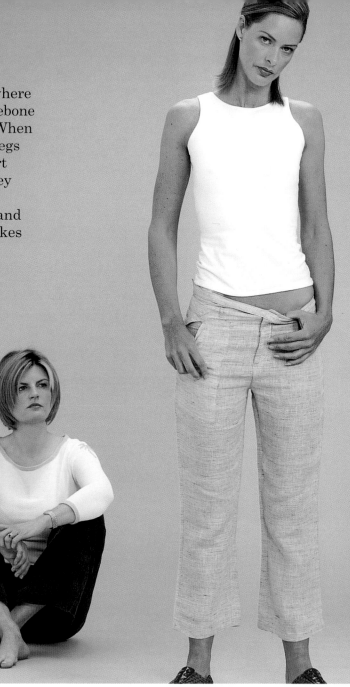

cropped

why: a trouser that ends anywhere above the anklebone is shortening. When people look at legs encased in short trousers, all they see is, well, the short trousers and this in turn makes short legs look even...shorter.

<u>or</u>

drainpipe jeans

why: far too tight leaving no room for manipulating the truth. Your short legs are left too exposed in these.

<u>and</u>

high-waisted trousers

why: these just visually increase the length of your back and highlight exactly how low-slung your arse really is.

palazzo pants

why: cover where your ass ends and your waist begins, thus making short legs appear longer.

alternative
colour co-ordination

why: wearing the same colour trousers, socks and shoes will elongate the length of the legs.

alternative
wide flares

why: the width of the flare will cover any shoe no matter how high. Just be sure they are long enough in your chosen footwear to still skim the floor.

anything too tight

why: will clutch around the bum giving away the terrible secret of having a bum that almost drags along the floor.

one worn over trousers

why: this is a great trick for disguising how short your legs really are because the trousers are shielded by extra coverage in the form of the dress.

long and high-waisted

why: like anything empire line, the dress flares from under the bust, glancing over the bum and therefore wiping it out completely.

best dress

short and alone

why: these leave a gap at the stomach which equates to not having long enough legs to rise up and meet the hem of the top.

two tops layered

why: if you have short legs, you'll have a long back to compensate for the stuntedness. Your expanse of torso needs to be broken up with layering, which will automatically make your legs look longer.

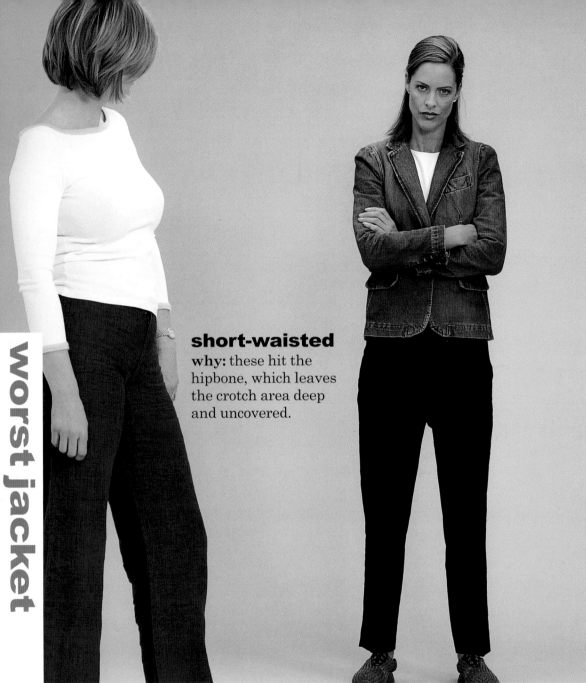

short-waisted

why: these hit the hipbone, which leaves the crotch area deep and uncovered.

three-quarter length

why: this is a great length as long as it is worn with trousers and heels, otherwise it will swamp you.

alternative
long-line

why: these are the ones that end just under the bum and show as much of the legs as possible.

bias cut ending mid-calf

why: this difficult length doesn't show enough leg to elongate it and too much to hide the fact that legs aren't your strong point.

or
long skirt and flat shoes

why: this is will make you look like a long-legged person...whose pins have been chopped at the knee.

long with
high heels

why: as long as the
shoes are covered all
will assume it's your
legs rather than the
shoes that are giving
you extra height.

calf length
with high boots

why: wear these in the
same colour and people
will focus on your high
butt perched at the top
of endless legs.

alternative
ending just below knee

why: not only is this the thinnest part of your
leg, but it leaves your entire calf open to the public,
thus giving it the opportunity to show its
maximum length.

	no guilt	**slight guilt**	**guilt for days**
trousers	Zara Top Shop Hennes	French Connection Whistles	Chloe Roland Mouret Miu Miu
dress	Zara	Joseph Whistles	Marni
top	Knickerbox Zara Top Shop Laundry	Whistles Michael Stone Fake London Jigsaw	Prada Chloe Alice Temperley
jacket/coat	Top Shop Hennes	Laundry Industry	Marni Chloe Missoni
skirt	Top Shop Zara	French Connection Jigsaw	Gharani Strok Alice Temperley Dries Van Noten

golden rules for short legs

Cropped trousers will only accentuate your lack of leg.

Never wear tight trousers – they will only draw attention to where your bum ends and your legs begin.

Always wear your hem to the ground when wearing trousers with high heels.

Never wear a skirt that has a second dropped waistband – your already short legs will halve again in size.

Dresses over trousers cover up where the legs begin.

Keep the colour flowing – same on shoe, sock and trouser.

If you can't walk in your high heels, they wont give you confidence.

Hang coloured clothes together as outfits – so you always have something to wear

Joint winner with pear-shape as the **least favoured body part** is the stomach. There are few women who are the proud owners of a toned tummy and those that are are either genetic freaks or work out relentlessly to achieve concrete control. The rest remain **burdened by flab** that has a life of its own. It's a ghastly affliction, this whole tummy thing, because the goal of any exercise programme is a six-pack. We're driven to believe that it's not possible to have a beautiful body with **fat hanging over your waistband**. This is terrible for any of us who have so much as looked at a doughnut or even thought about sprogs, let alone heaved one of the wretched things out. We understand that childbirth, like a normal, healthy appetite can do terrible things to the body, but without surgery it's damn near impossible to firm up skin that has been stretched beyond redemption. So, **if you can't beat it, conceal it**.

skin-clinging

why: there is nothing worse than a too-tight bra strap being shown slicing through excess fatty tissue in a spray-on t-shirt. Added to this, a front view of rippling flab dribbling down one's side is enough to make Samson want to remain blind.

or
short t-shirt

why: t-shirts that end an inch or two above your waistband allow the largest roll to burst through.

shirt-tail hem

why: these scoop down and gently cover the tummy at the front, whilst lifting at the side to reveal a hopefully slimmer hip bone.

alternative
slim-fit

why: as long as it doesn't claw at the fat a skinny-fit t-shirt fines a bulky torso down, because you look neat and therefore trim.

alternative
mid-length tops

why: a hem that stops in the middle of the tummy visually breaks up the bulge.

alternative
tight over tits

why: a snug fit around the boobs will mean looser fabric on tummy, allowing the jugs to take centre stage.

tight vest

why: these always ride up over the rolls to reveal a pillow of flab hanging over your waistband.

ruched top

why: no one will know if it is the fabric or your flesh that is making the waves.

alternative
wrap top

why: the ties are unusually high enough to winch in the waist, leaving the skirt of the top to swathe over the tummy.

7

spray-on lycra

why: you look like too much meat stuffed into a sausage skin.

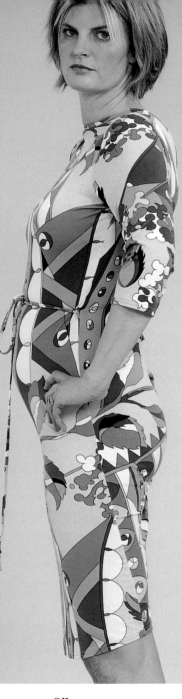

worst dress

<u>or</u>

kaftan

why: if you are large anywhere these make everything else look even more enormous.

alternative
wrap dress

why: exaggerate the folds and you camouflage the tummy.

alternative
empire line

why: the focus is on the breasts with the fabric falling from just beneath them. This acts as a tent without hiding your entire figure.

low-slung waist

why: this will cling around the hips, acting as good a cover-up as a wide belt over your tummy.

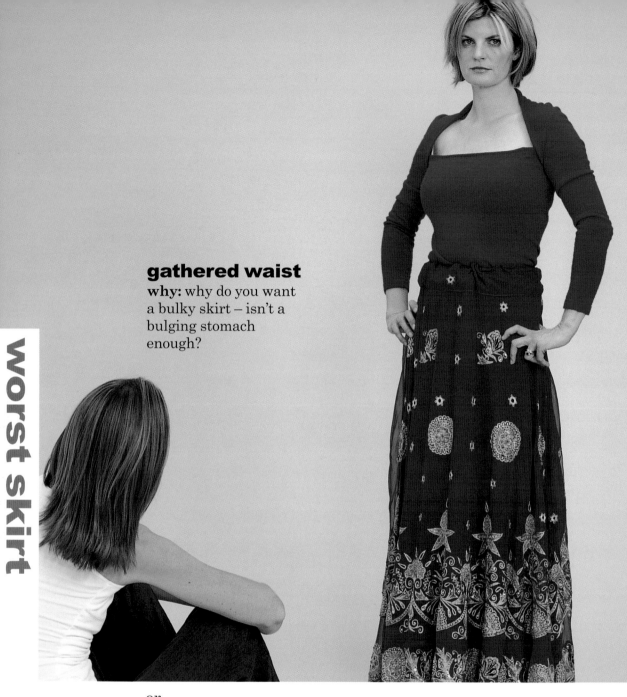

gathered waist

why: why do you want a bulky skirt – isn't a bulging stomach enough?

or

straight-cut skirt

why: the skirt will hang from the continental shelf of flab making your entire pelvic area look huge.

**sarong skirt for the more mature
or sarong for the younger woman**
why: movement of folds hides the motion going
on underneath.

ruched front

why: the folds
deflect the eye from
the flab.

low-waisted

why: waistband
cuts across stomach
making it half
the size.

best skirt

too tight, jean-cut

why: the stomach spills over the garrotting waistband.

or.

hipsters

why: too low to hide any stomach or leave a tummy with any dignity whatsoever.

flat-fronted with side zip

why: holds in tummy with no fuss at the front to bulk it up.

magic knickers

why: these are the only suck-in pants that hoick up the arse and hold in the tummy without the squeezed excess spilling over the top like a frothing pint of Guinness. A must for every tummy carrier.

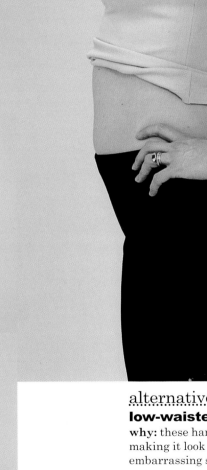

alternative
low-waisted jeans one size too big

why: these hang loose around the waist making it look like the jeans are too big for your embarrassing secret.

belted

why: the belt creates gathers that increase the width of your uncontrollable girth.

worst coat

alternative
single-breasted buttoning from waist
why: left undone, this leaves only a sliver of the underneath on show, which is very slimming.

short-waisted and fitted

why: the tight waist will encourage the peplum to flare over the tummy like a little brim.

	no guilt	slight guilt	guilt for days
t-shirt	Top Shop	Joseph Agnès b Jigsaw	Studd Chloe Boutiques in general
top	Top Shop Hennes	Whistles Jigsaw Georgina Von Etzdorf	Tracy Feith Miu Miu Missoni
trousers	Hennes Zara Gap Mango	Jigsaw Joseph French Connection Nuala by Puma	Earl Jean Anna Molinari Donna Karen
skirt	M&S Monsoon	Whistles 120% linen	Rozae Nichols Allegra Hicks
jacket	Top Shop Zara	Jigsaw Joseph Dosa	Chloe Dries Van Noten Dolce & Gabbana

golden rules for flabby tummy

Never wear hipsters.

No skintight shiny fabrics.

Make sure clothes skim rather than cling.

Empire line dresses and tops hide the rolls.

Don't wear your belts too tight.

Make sure tops hang from tummy rather than go underneath it.

Don't be tempted to pierce a flabby bellybutton.

No cropped tops, even on puppy fat.

Style is wearing something no one else has

golden rules

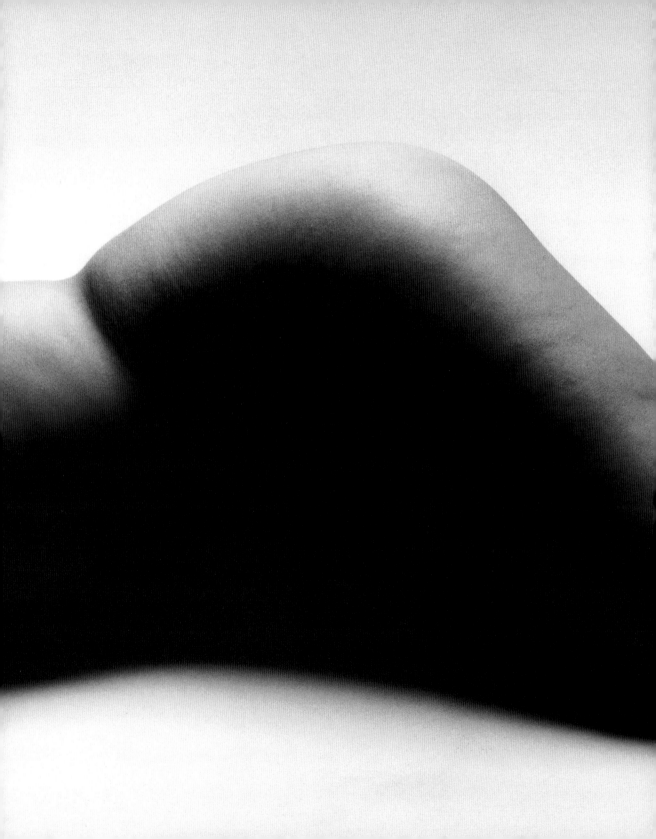

Excess fat at the side of the hips is an affliction common to millions of women. Like cellulite, it is **a burden carried by the female sex alone**. Unless a man is truly obese, they are saddlebag free. Saddlebags have the ability to make a skinny woman reach for the diet pills. The **'Does my ass look big in this?'** question will come into her head every time she gets dressed. 'Yes, it does,' comes our reply, 'because you insist on wearing clothes that act as a neon sign to your expanding rear.' If you are pear-shaped and carry your weight at the sides of your hips you'll doubtless find it hard to track down **decent-fitting trousers** and skirts that sit neatly on your waist and hips. You can then blame the size of your arse on the clothing industry, but isn't it better to be responsible for making the problem disappear?

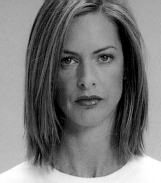

big, white and baggy

why: even at the best of times these t-shirts...actually there are no best times with baggy t-shirts except when used as dusters...they turn a slightly distorted human being into one that has no waist as well as a pear-shaped bottom half.

slash neck

why: the width of the
neckline balances out the
width of those hips.

long wrap

why: wrap tops are a fabulous garment for reducing tits and creating a waist, because the upper half of the top is nurturing these areas. In the case of saddlebags, it's the hem that has to do the work and sadly it's just not able to fit around stuffed hips. Try it yourself and you'll see the hem splays out at the widest part of your arse.

worst sweater

one that fits snugly and sits at the top of hips

why: clean, excess-fabric-free lines keep you slim atop, whilst a hem length that stops before the hips serves to reduce the waist to the extent that no one gives a toss about those bags.

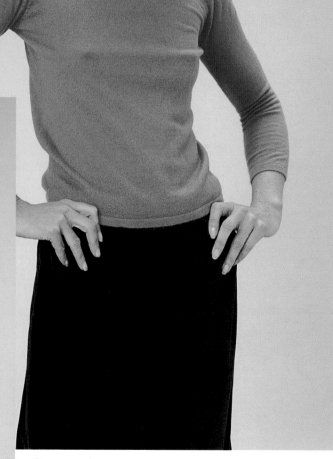

alternative
cropped top

why: if you have saddlebags you will almost certainly have a narrower torso – hence the term pear-shaped. The best way of showing this off is to show a cheeky bit of tummy above not-too-tight hipsters.

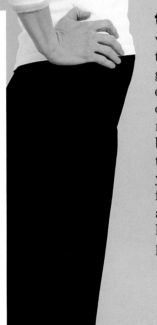

tapered

why: we despise tapered trousers beyond all other garments. They should be outlawed from all corners of the globe and a maximum penalty should be given to those who wear them with saddlebags. If you have a pair, burn them, for the narrowness of the ankle only magnifies your hips by earth-shattering proportions.

or
straight leg

why: even these aren't wide enough at the hem to balance out your hips.

and
drainpipe jeans

why: these are the kiss of death for pear-shapes. All those rivets, pockets, belt loops and zips are too much for what's big and broad. This, coupled with skinny ankles, makes getting through the door become a daily hazard.

flares

why: bring back the Seventies and keep them there. Even if flares become unfashionable, saddlebag holders should hang on to them for dear life, for they are the only trousers that can reduce your bags to relative insignificance.

alternative
palazzo pants

why: the loose-fit fabric hangs from the bags erasing all knowledge of anything untoward going on underneath them.

best trousers

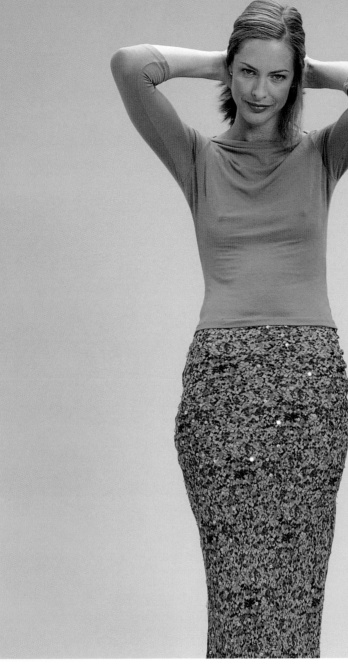

bias cut

why: the cross cut of the material makes it cling like a newborn on the breast to your hips. This is great for the hourglass, but style suicide for the pear-shape because it makes thunderous thighs positively torpedo-like.

or

pencil shape

why: too tight for pear-shapes. Your saddlebags might as well be enlarged by the Hubble telescope and put on show at the Tate Modern so gross-making are these skirts for you.

A-line in any length

why: the material glides over and continues past the physical catastrophe, making it impossible for onlookers to become aware of your dark secret.

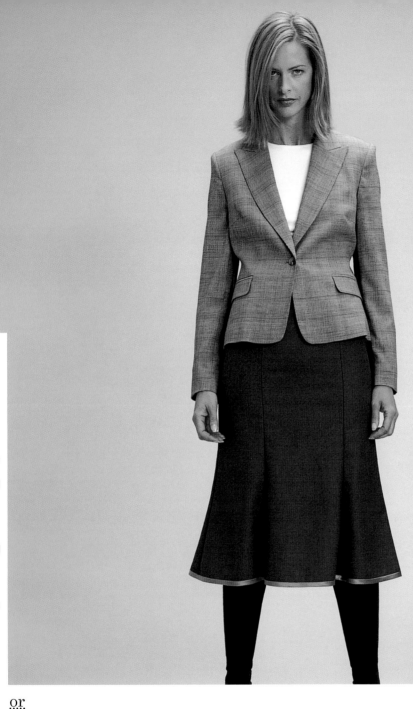

hacking jacket

why: any jacket that hits your hips at their widest part is terrible for you. You can get away with something shorter worn with an A-line skirt, but that proverbial hacking jacket length adds unnecessary stress to an already strained pair of hips.

or
funnel coat

why: if it fits around your arse, it won't fit anywhere else.

three-quarter length with flared hem

why: like an A-line skirt, the coat will wipe out the saddlebags.

large lapels

why: a bold lapel balances out a broad beam by widening your chest and shoulders to keep up with the hips and create more of a waist.

8

	no guilt	slight guilt	guilt for days
top	Top Shop Zara Oasis	Velvet Dosa	Marni
sweater	French Connection Zara	Ballantyne	Marni
trousers	Zara	French Connection Jill Stewart	Marni Giorgio Armani
dress	Zara	Dosa Joseph	Marni Elspeth Gibson
coat	Hennes Zara Top Shop	Whistles French Connection Jigsaw	Prada Miu Miu Marni

golden rules for saddlebags

Never wear skirts or dresses cut on the bias – unless you want everyone to focus on your biggest defect.

Never wear jackets to the hip as you will only accentuate your thunder thighs.

Remember to balance out your shape by wearing A-line skirts and bootleg or flared trousers.

Coats are better than jackets.

Leggings are for the gym and nowhere else.

Put on an outfit you never end up wearing. Ask yourself exactly why it is not flattering.

Keep it all tidy – it will only work if you can find it

You may think a short neck is of little or no importance. In fact, even if you have one you probably haven't noticed that your head grows straight from your shoulders. You are no doubt living in a long-necked paradise, bedecking yourself with all manner of **neck-throttling torture**. We can see you strangled by polo necks and hard for breath in a nonchalantly tied neckerchief. Handled badly, **a short neck can be aesthetically ruinous**. Look around you and pick out a chunky, clumping beast of a woman. She may be thin or fat, tall or short, but something about her makes her hulk-like. Look closer and we bet you it's her **badly clad neck** that is turning into our round-shouldered friend from Notre Dame. Short necks have the ability to **make the thin look fat**, the pretty ugly and when burdened by an extra chin or too, the young old before their years. Unfortunately, no lengthly starvation or deft handling of the scalpel is going to give the chinless a jaw or the neckless one worthy of a swan. This **can only be corrected by deception**.

turtleneck

why: as this poor man's polo neck travels halfway up the neck it leaves only the other half of what is an already pathetically short physical feature.

or
polo neck

why: if your lack of neck is also afflicted by an additional chin or two, they will hang over the top of the neck and you'll look like a turkey with a thyroid problem.

and
round neck

why: still too high for any kind of superficial elongation to have an effect.

alternative
wide scoop

why: reveals more of the shoulders, which, when pushed down by good posture, makes the neck longer and more elegant.

deep V

why: opens up the whole chest area to create maximum exposure, which lengthens the neck.

Nehru

why: acts in exactly the same way as a turtleneck, which means aesthetic asphyxiation by a collar that looks too tight and over-powering for your impeded neck growth.

<u>or</u>
collarless shirt

why: these are a mistake, especially for double chins. They do neither one thing nor the other and the loose flesh will overflow, making it the first thing you see appearing from the neckline.

turned-up
shirt collar

why: the height of the collar gives rise to a neck emerging gracefully from its folds. Be sure to button the shirt low to further elongate your neck.

best collar

a choker

why: will look more like a dog collar on a very dense bull terrier than a glamorous neck adornment. It's too overpowering for something so underdeveloped.

worst necklace

a fine choker

why: because of the delicate nature of the necklace, it gives your neck more room to shine on its own without being smothered.

no earrings

why: a short neck deprived of earrings is a short neck left spread-eagled to scrutiny. Hanging down the side of it, earrings act as blinkers that blind the eye to the inadequate length of your gullet.

worst earrings

chandeliers

why: if the earring is long it will reflect its length on your neck. What happens is that the earrings carry the neck length up to your ear lobe as opposed to your jaw.

	no guilt	slight guilt	guilt for days
top	Gap	French Connection	Joseph
	Mango	Jigsaw	Anna Molinari
	Jane Norman	Whistles	Yves Saint Laurent
		Karen Millen	Stella McCartney
jewellery	Accessorize	Mikey	Erickson Beamon
	Top Shop	Butler & Wilson	Me&Ro
		Agatha	
shirt	Etam	Whistles	Jill Sander
	Zara	DKNY	Comme des Garçons
	Next	Calvin Klein	Paul Smith
	M&S	Dolce & Gabbana	DKNY
	Oasis	Max Mara	Dolce & Gabbana
	River Island	French Connection	Calvin Klein
		Karen Millen	Ralph Lauren

golden rules for short neck

The only time you can get away with a lot of gold is when it's in your mouth.

Short necks that hold a small head must never wear thick necklaces.

Long earrings are more flattering.

The longer the distance of flesh to the tits – the longer the neck will look.

Turtlenecks will only enhance a squat neck.

Don't loop a pashmina – wrap it around twice.

The more flesh you show on your cleavage, the longer your neck will look.

Chuck out the clothes that don't suit you – even if you think of them as old friends.

golden rules

Reassess your hairstyle.
Has it been the same for many years?
It may be safe but perhaps it's time for a change

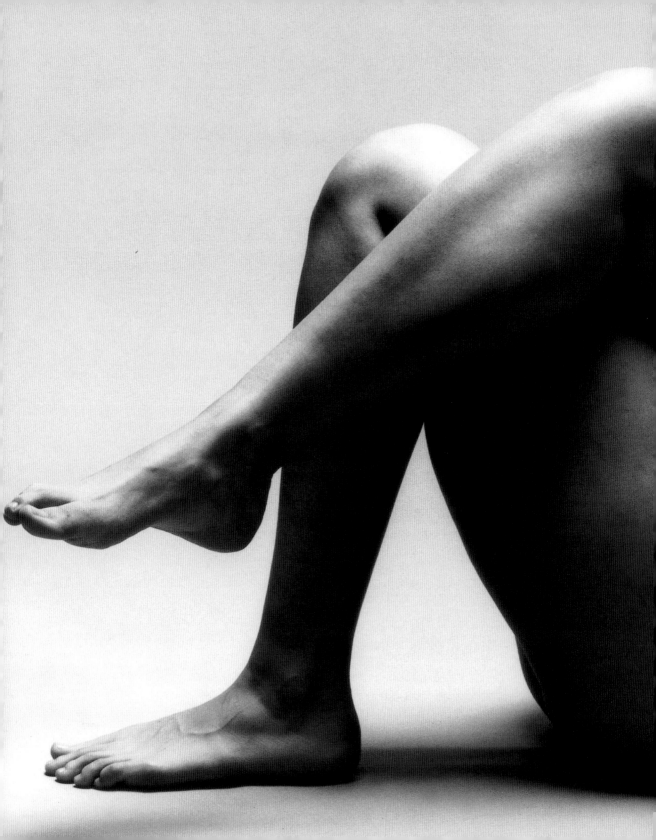

What makes a great Thoroughbred? Its ability to run like the wind thanks to fine-boned ankles. Thick ankles, by the same token, signify a more common breed in keeping with the Cob or Shire horse. Appreciated for their talent for pulling heavy goods and capacity to trudge through deeply ploughed furrows, their chunky fetlocks have long been revered by farmers and pit proprietors alike. Although we're not suggesting the only place a pair of **chunky human ankles** can get by is down the mine or knee deep in manure, it would be fair to say that they **should be disguised whenever possible**. As should **a stout calf**, which can make even the skinniest women feel hefty and unfeminine. Summer is the worst enemy. Whilst trousers are a great provider of camouflage and come in featherweight fabrics to keep you cool, you can't always be encased in slacks (and they provide an altogether different set of problems if they are the wrong shape). It's nice to **show a bit of leg** occasionally. So if you find a skirt length, and more importantly a shoe, to flatter your leg, then the heat can become your friend. The winter, of course, is heaps easier, as skirts of all lengths can be teamed with boots. But at the end of the day **the solution lies in becoming a master of illusion**. Do what David Copperfield does with aeroplanes and your ankles will disappear in a puff of smoke.

cropped to ankle

why: any trouser that ends mid-calf is a flying flag waving to a lower leg devoid of shape.

or
leggings
why: why bother wearing anything at all? Not only can we see the cellulite, but your criminal calves are going to get busted for blatantly flouting the law.

and
tapered jeans
why: there is a no more grotesque look than a calf getting caught up in the cling of jeans.

flared

why: no fabric can grip unbecomingly to the calf – instead, all is hidden and the leg is elongated when extra length hides a killer heel.

calf length

why: a thick calf in a medium-length skirt reminds us of an iceberg, only in this case it's the disproportionately large underbelly of it that's on display.

<u>or</u>
bias cut

why: a cross-cut fabric is born to cling seductively to the body. This means that anything appearing from below the hem will look huge by comparison.

<u>and</u>
ankle length

why: the only things poking out from underneath will be your podgy ankles, making their very existence the sad focal point of your outfit.

A-line to the knee

why: the wider the skirt the slimmer the ankle and calf will appear.

ankle strap on the ankle

why: encircling the offending ankle will make it look like it's being throttled, thus drawing concerned attention to its welfare.

or
kitten-heel mule

why: the weight of the calf looks like it's not supported by the delicate heel and the closed toe chops the foot in half, thus visually depriving the leg of a good 3 or 4 inches.

and
pointed flat slip-on

why: the ankle is constricted by the delicacy of the shoe and appears even larger. These shoes also have a tendency to swell up the feet – making the ankle a total catastrophe.

open-toed, chunky-heeled sandal

why: the ankle is elongated right down to the toes, giving the appearance of a thinner leg.

alternative
wedge heel

why: the wedge is heavy enough to balance out the thickest of calves.

no boot

why: if you don't hold a pair of boots in your wardrobe, get out there now as they will make skirt wearing a joy.

or
calf-length boot

why: the meatiness of the calf will overflow. These are fine when the top of the boot is hidden.

and
ankle boots

why: this is a very dangerous form of footwear – it makes even the most refined legs look large and tarty. Fine under trousers, but put them on a thick calf and you'll see they are the worst accessory possible.

pull-on, tight around the ankle

why: although difficult to locate, this shape that ends just under the knee is the best look. The calf is entirely covered up and they also work miracles on thick ankles. In fact, with these pull-ons, the bulkier the ankle the better.

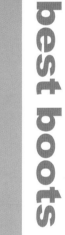

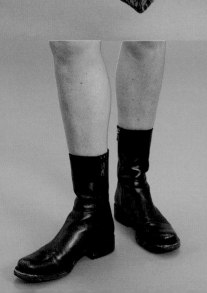

alternative
high ankle boot

why: by hiding the ankle until the calf zone, the thickness is entirely hidden and well disguised.

	no guilt	**slight guilt**	**guilt for days**
skirt	Top shop	Tracy Boyd	Dries Van Noten
	Zara	Karen Millen	Marni
	Warehouse	Jigsaw	Alice Temperley
		French Connection	Gharani Strok
		Reiss	
trouser	Zara	French Connection	Chloe
	Miss Sixty	Jasper Conran for	Roland Mouret
	Diesel	Debenhams	Plein Sud
	Hennes	Earl Jean	Marni
		Fenn Wright & Manson	Dolce & Gabbana
		Plenty	Giorgio Armani
		Paul Smith	
		Nougat	
shoes	Zara	Karen Millen	Rodolphe Menudier
	Nine West	L.K. Bennett	Dolce & Gabbana
	Dune	Bertie	Prada
	Faith	Kurt Geiger	Miu Miu
	River Island	Emma Hope	Versace
	Shelleys		
boots	Zara	Karen Millen	Jane Brown
	Faith	Joseph	Sergio Rossi
	Debenhams	Hobbs	Tod's
			Stephan Kelian
			Christian Louboutin

golden rules for thick ankles and calves

Kitten heels are unkind to thick ankles.

Never encircle the ankle – a strap should only be seen below.

Clingy skirts only emphasis the width above the foot.

Long skirts are made for thick ankles (even if you are under 5'2").

Boots are the saviour for thick calves.

Never wear capri pants.

Never wear leggings except to the gym (and if you're single don't even go there).

Never wear three-quarter-length dresses or skirts.

Black and brown shoes should never be worn with pale outfits

Stockist numbers for high street shops around the UK

Accessorize
020 7313 4000
149 stores
www.accessorize.co.uk

Agnès b.
020 7225 3477
6 stores
www.agnesb.fr

Benetton
020 7389 8120
120 stores
www.benetton.com

Bertie
020 7380 3800
300 stores

Bhs
020 7262 3288
160 stores
www.bhs.co.uk

Coast
020 7490 9999
15 including concessions

Diesel
020 7833 2255
14 stores
www.diesel.com

Dorothy Perkins
0870 122 8801
560 stores
www.dorothyperkins.co.uk

Dune
020 7258 3605
24 stores

East
020 8877 5900
39 stores and over 300 stockists

French Connection
020 7399 7200
60 stores
www.frenchconnection.com

Gap
0800 427 789
140 stores
www.gap.com

Hennes
020 7323 2211
63 stores
www.hm.com

Hobbs
020 7586 5550
34 stores

Jigsaw
020 8392 5656
42 stores

Jones Bootmaker
0800 163 519
70 stores
www.jonesbootmaker.com

Karen Millen
01622 664 032
44 stores
www.karenmillen.com

Knickerbox
01883 629 320
34 stores including concessions
www.knickerbox.co.uk

Kookaï
020 7368 6903
28 stores + 26 concessions
www.kookai.co.uk

L.K. Bennett
020 7491 3005
22 stores
www.lkbennett.com

Long Tall Sally
020 8649 9009
26 stores
www.longtallsally.com

Marks & Spencer
0845 603 1603
306 stores
www.marks-and-spencer.com

Matalan
01695 552 793
145 stores
www.matalan.co.uk

Mikey
020 7287 1232
13 stores

Miss Selfridge
0870 122 8811
168 stores

Miss Sixty
020 7700 6470
10 stores including concessions
www.misssixty.com

MK One
020 8993 6262
156 stores
www.mkone.co.uk

Monsoon
020 7313 3000
148 stores
www.monsoon.co.uk

Morgan
0800 731 4942
58 stores

Muji
020 7323 2208
16 stores
www.muji.co.uk

New Look
0500 454 094
486 stores
www.newlook.co.uk

Next
08702 435 435
330 stores
www.next.co.uk

Oasis
01865 881 986
130 stores
www.oasis-stores.com

Office
020 7566 3070
12 stores
www.office.co.uk

Petit Bateau
020 7838 0818
2 stores + a concession in Selfridges
www.petit-bateau.com

Press & Bastyan
01622 763 211

Principles
0800 731 8286
231 stores
www.principles.co.uk

Ravel
01458 843 2202
50 stores

River Island
020 8991 4759
200 stores
www.riverisland.co.uk

Russell and Bromley
020 7629 6903
42 stores
www.russellandbromley.co.uk

Top Shop
0800 731 8284
308 stores
www.topshop.co.uk

Uth
020 7240 5651
6 stores
www.uth.com

Wallis
0800 915 9901
268 stores

Warehouse
0800 915 9902
175 stores

Zara
020 7534 9500
11 stores
www.zara.com

Boutiques

It is worth pointing out that when we recommend specific boutiques, it is because we know how the owners buy each season and what their shape is. This does tend to reflect how they buy (whatever they might say). i.e. the sexy, buxom and sultry owner of Mimi does take into account the size of her cleavage, so the shop is fantastic for those with big breasts. Likewise, Wilma on the Portobello Road in London might have owners of contrasting shapes, but their taste is for the modern woman who has not lost sight of her femininity.

Bath

Jaq

16 Margarets Buildings
Bath BA1 2LP
01225 447 975

Megan Park, Rebecca Davies, Collette Dinnigan, Gina, Lulu Guinness, Michael Kors, Sophia Kokosalaki, Angela Hall

Specialise in the timeless pieces from each collection, clothes with staying power. Jackie, the owner, buys what she herself would want to wear.

Square

5–6 Shires Yard
Off Milsom Street
Bath BA1 1DZ
01225 464 997

Gucci, Prada mainline, D&G, Chloe, Stella McCartney, Alexander McQueen, Fake London, Voyage, Paul Smith, Plein Sud, Earl Jean, Burberry, Shirin Guild, Marni, Ghost, Matthew Williamson, Anna Molinari, Blumarine, Joseph, Moschino

Ensure a great choice and wide selection for all their customers. John and Lyn buy the fashion end of collections and go for the unique and individual pieces.

Birmingham

Flannels

14 Lower Temple Street
Birmingham B2 4JD
0121 633 4154

Gucci, Prada, Giorgio Armani, Alexander McQueen, Stella McCartney, Etro, Joseph, Fake London, Evisu, Maharishi, Fendi, Replay, Juicy Couture, Jimmy Choo, D&G, Burberry, Voyage, Plein Sud

Excellent choice of high-fashion designers. A chain of well-stocked boutiques in many locations outside London.

Katherine Draisey

58 Drury Lane
Solihull B91 3BH
0121 704 2233

Matthew Williamson, Paul Smith Women, Ben di Lisi, Jenny Packham, Caroline Charles, Laura Biagiotti, Artwork, Betsey Johnson, Belville Sasoon, Cacharel, La Perla, Trixi Schober, Clips, Gabi Lauton, Ane Kenssen, Maria Grazia Severi

Pride themselves on their personal shopping service and will arrange appointments after hours if required. Half their stock is bought with certain customers in mind; the other half is wacky fashion and classics with a twist. Evening wear specialists.

Buckinghamshire

Chantel

41 High Street
Marlow
Bucks SL7 1BA
01628 484 960

Iceberg Jeans, Luisa Lorenzi Knitwear, Via Emilia, Votre Nom Jeans, Exte Jeans, Roccobarocco

Eclectic mix of European fashion.

Cambridge

Giulio

5 Sussex Street
Cambridge CB1 1PA
01223 423 776

Prada mainline, Prada Sport, Gucci, Etro, Paul Smith Women, Fake London, Fake Genius, Burberry, Pringle, Earl Jean, Wale Adeyemi, Velvet

Appeal to all ages with an across-the-board selection of style. Will travel as far as Inverness to loyal customers to show them the new collections and recommended pieces.

Hero

3 Green Street
Cambridge CB2 3JU
01223 328 740

Alice Temperley, Joseph, Ghost, Nicole Farhi, Save the Queen, Fornarina, Shirin Guild, Betsey Johnson

Buy styles across the board, for all ages. Owners buy what they would like to wear.

Hero Shoes

As above

Emma Hope, Robert Clergerie, L.K. Bennett, Luc Berjen, Ego, Jane Brown

New store opening autumn 2002.

Cheshire

Garbo

Stratstone House
Altrincham Road
Wilmslow
Cheshire SK9 5NN
01625 521 212

Emmanuel Ungaro, D&G, Roberto Cavalli, Blumarine, Maharishi, Plein Sud, Voyage Passion, Chloe, Gharani Strok, La Perla, Matthew Williamson, Burberry, Missoni, Juicy Couture, Jimmy Choo, Gina

Style is funky, trendy, feminine and sensual, ensuring that Jane's boutique is in the little black book of many celebrities.

Edinburgh

Corniche

2 Jeffrey Street
Edinburgh EH1 1DT
0131 556 3707

Yohji Yamamoto, Comme des Garçons, Vivienne Westwood, Fake London, Thierry Mugler, Voyage, Escada, Arkadius, Jean Paul Gaultier, Betsey Johnson, Issey Miyake, Natalie Garcon

Nina stocks sizes 8–14. Buys quite artily, works with gut feeling. Key pieces can be found here. She does not buy too many classics.

Cruise

94 George Street
Edinburgh EH1 1SU
0131 226 3524
also at
14 St Mary's Street
Edinburgh EH2 3DF
0131 220 4441

Burberry, Prada, Prada Sport, D&G, D&G Jeans, Barbara Bui, Cavalli, Hugo Boss Women, Paul Smith Women, Chloe, Joseph, Earl Jean, Duffer, APC, Antoni & Alison, Alexander McQueen, Replay, Alice Temperley, Giorgio Armani Collezioni

Provides a wide range of styles, from funky street wear to elegant evening attire. A well-stocked boutique in key locations in the North.

Essex

Blue Lawn

19 Baddow Road
Chelmsford
Essex CM2 0BX
01245 250 083

DKNY Pure, Twinset, Paul Smith, Whistles, Ghost, Luna Bi, Peter Golding, Moschino, White Stuff, Crew, French Connection, Chloe swimwear, Dinny Hall, Erickson Beamon, Betsey Johnson, Poleci, Rebecca Sanver

Claire buys for customer base in mind, from tiny 8s to bigger girls. For compulsive shoppers there is always something new in the shop each week.

Shop 77

77 Queens Road, Buckhurst Hill
Essex IG9 5BW
020 8505 5111

D&G, Prada, Plein Sud, J-Lo, Cacharel, Maharishi, Studd, Balenciaga, Gina, Creed, Mudd Jeans, Michael Stars, Seven Jeans, Juicy Couture, Lucilla, Joomi Joolz

Buy unknown makes and customer favourites: exclusive different pieces, from the extreme to the ultra-wearable. The mood of the store is unique.

Exeter

Willys

24 Gandy Street
Exeter EX4 3LS
01392 256 010

Juicy Couture, DKNY, Bruns Bazar, FrostFrench, D&G, Maharishi, Paul Smith, Day, Jean Paul Gaultier, Paul Smith, Plein Sud, Earl Jean, Philosophy, See by Chloe, Bikini, Ghost, Philip Treacy, Finn Jewellery, Luc Berjen, L'Autre Chose

Susi has a very broad client base, including lots of students for ball dresses. Buys like a Londoner – funky and different. Her older customers don't want to feel middle-aged.

Glasgow

Cruise

180–188 Ingram Street
Glasgow G1 1DN
0141 572 3232

Burberry, Prada, Prada Sport, D&G, Barbara Bui, Cavalli, Hugo Boss Women, Paul Smith Women, Chloe, Joseph, Earl Jean, D&G Jeans, Duffer, APC, Antoni & Alison, Alexander McQueen, Replay, Alice Temperley, Giorgio Armani Collezioni

Provides a wide range of styles, from funky street wear to elegant evening attire. A well-stocked boutique in key locations in the North.

Hampshire

Moda Rosa

35 West Street
Alresford
Hampshire SO24 9AB
01962 733 277

Matthew Williamson, Clements Ribeiro, George Rush, Ben di Lisi, Caroline Charles, Nicole Farhi, Donna Karen, Amanda Wakeley, Gina, Betsey Johnson

Buy with their loyal customers in mind. Choose pieces for their individuality yet do not compromise on wearability.

Kent

The Changing Room

8 High Street
Tunbridge Wells
Kent TN1 1UX
01892 547 899

Chloe, Martin Sitbon, Paul Smith, Margaret Howell, Juicy Couture, Philosophy di Alberta Ferretti, Fake London, Paule Ka, Emma Hope

A boutique that concentrates on wearable, colourful garments. The owner buys items that she loves and relishes her loyal customer base.

Lancashire

Velvet

5 King Edward Terrace
Gisburn Road
Barrowford
Lancashire BB9 8NJ
01282 699 797

DKNY, John Richmond, Plein Sud, Poleci, Max Mara, Fake London, Strenesse Blue, Paola Frani, Caractére, Marc Cain

Deborah stocks sizes 8–16. She is very aware of English shapes: being tall herself and a slight pear shape, trouser length and size of thigh are very important.

Leeds

Strand

27 Queen Victoria Street
Leeds LS1 6BE
01132 438 164

Stella McCartney, Chloe, Paul Smith, John Richmond, Burberry, Miu Miu, Day, D&G

Customers early 20s–40s. The owners buy for young girls who want to stand out from the crowd. They are well stocked across the board.

Liverpool

Cricket

10 Cavern Walk
Liverpool L2 6RE
0151 227 4645

Stella McCartney, Juicy Couture, Cacharel, Marc Jacobs, Matthew Williamson, FrostFrench, Missoni, Roland Mouret, Sergio Rossi, Chloe

Buy with the very fashion-conscious customer in mind. Stock is usually from the top end of the collections. Young clientele aged 16–30.

Wade Smith

Mathew Street
Liverpool L2 6RE
0151 255 1077

Prada, Gucci, Burberry, Armani, Paul Smith, Versace, Valentino, Day, Calvin Klein, D&G, Chloe, Sticky Fingers, Joseph, John Richmond, Franklin & Marshall, C.P. Company

A vibrant store with a youthful customer base. The owners know their clients well and will buy with them in mind, but they also ensure that there is always a wide choice for their more mature customers.

London E

Frock Brokers

Port East Buildings
14 Hertsmere Road
London E14 4AF
020 7538 0370

Gharani Strok, Fake London, Megan Park, to name a few

Warehouse specialising in samples and end-of-season gear at bargain prices. Fight over many labels and one-off pieces.

Sublime

99 Lauriston Road
London E9 7HJ
020 8986 7243

Ann-Louise Roswald, Sara Berman, Saltwater, Marilyn Moore, Gotham Angels, Day, Harrison, Donna de Franq, Out of Xile, Jay Clark, Petit Bateau

Well stocked with unique one-offs. Buy with specific customers in mind.

London N

Gotham Angels

23 Islington Green
London N1 8DU
020 7359 8090

Gotham Angels, W<, Fornarina, Fiorucci, Roxy Quicksilver

Buy a little of the extreme, a lot of the middle of ranges. They buy unique pieces and also what suits their regular customers.

Hoxton Boutique

2 Hoxton Street
London N1 6NG
020 7684 2083

House of Jazz, Future Classics, Exquisite J, Carlota Joaquina, Laura Bou

Stock lots of things they like: eye-catching pieces ranging from the extreme to the middle.

London NW

Anna

126 Regents Park Road
London NW1 8XL
020 7483 0411

Nicole Farhi, Orla Kiely, Rutzou, Saltwater, Ann-Louise Roswald, Maharishi, Red Hot, Holly, Tania, Alice Temperley, Velvet, Designers Remix

A boutique that doesn't follow trends but provides wearable feminine clothes that will not date. Classics with the quirky thrown in for good measure. Owner Anna keeps an eye on up-and-coming designers.

Genevieve

5–6 Monkville Parade
Finchley Road
London NW11
020 8458 9616

Matthew Williamson, Betsey Johnson, Paul Smith, Ben de Lisi, Juicy Couture, Maharishi, Elle, Fake

Buy a wide range of casual and evening pieces. High fashion mixed with comfort.

Hannah Lee

77 & 92 St John's Wood High Street
London NW8
020 7586 4121

Ghost, Chloe, Luella Bartley, Plein Sud Jeans, Cosabella, Twinset, Hooch, Paul Smith, William B, Three Dots, Holly, Orla Kiely, Studd, Red Hot, Techno Marine Watches. Also a good selection of American jewellery

Hannah and Helen, the girls at Hannah Lee, buy very much according to their own taste. They know their customers well, so buy with them in mind too. Don't go for the extreme ends of collections.

YDUK

84 Heath Street
Hampstead
London NW3 1DN
020 7431 9242

Studd, Fake London, Dirty Youth, Custo, Hooch, Wale Adeyemi, Skipping Girl

Stock a very extensive range of urban wear.

London SE

?Air

85–87 Dulwich Village
London SE21 7BJ
020 8299 4252

Claudette, Vivienne Westwood, Issey Miyake, Pleats Please, Shirin Guild, Roberto Cavalli, Betsey Johnson, Holly, Nuala, Pringle, FrostFrench, Orla Kiely, Rachel Robarts, Patrick Cox, Hamnett, Joseph, Juicy Couture, Seven, Maharishi, Paul Smith

A wide selection in fab locations in the southeast.

London SW

?Air

86 Church Road
Barnes
London SW13 0DQ
020 8748 1172

also at

77–78 High Street
Wimbledon Village
London SW19 5EG
020 8946 6288

Claudette, Vivienne Westwood, Issey Miyake, Pleats Please, Shirin Guild, Roberto Cavalli, Betsey Johnson, Holly, Nuala, Pringle, Orla Kiely, Rachel Robarts, FrostFrench, Patrick Cox, Hamnett, Joseph, Juicy Couture, Seven, Maharishi, Paul Smith

Extensive selection of great labels. Offers huge range of choices for any age, shape and size.

A la Mode

10 Symons Street
London SW3 2TJ
020 7730 7180

Marc Jacobs, Sybilla, Marni, Chloe, Victor and Rolf, Etro, John Galliano, Cacharel, Stella McCartney, Emmanuel Ungaro, Valentino accessories

The owners support many designers from their first season and have a nose for who has staying power.

Ajanta

21 Motcomb Street
London SW1X 8LB
020 7235 1572

Sybil Stanislaus, Geen Morgan, Santa Croce, Missoni

If you are the owner of large breasts and have always found it difficult to find unusual evening wear, look no further. Their fitted kaftans in sensational Indian fabrics are exquisite.

Boho

113A Northcote Road
London SW11 6PW
020 7924 7295

Poleci, Lui J, Milona X, Paola Frani, Day, Gerard Darel, Custo

Owner Johanna buys a selection of eye-catching items as well as a great choice of wearable pieces. The shop has a loyalty card system in place.

Controversy

44 Queenstown Road
London SW8 3RY
020 7720 8722

W<, Adéle, Gordon McQueen, Yanky Candles, Sylvia Rielle, Coutura, Soochi, Bill Tornade, Cheyenne

Glo Vanlit has an eye for unique eye-catching garments. Practically inform their customers what they will be wearing the following season!

Designer Club

9 West Halkin Street
London SW1X 8JL
020 7235 2242

Chloe, Randolf Duke, Roberto Cavalli, Galliano, Emmanuel Ungaro

This is the ultimate Eurotrashes' mecca whilst living in or visiting London. Guaranteed to have all the key pieces from each season.

EG Butterfly

70 New Kings Road
London SW6 4LT
020 7371 9291

Yantha, Rachel Robarts, Baladina, Fornarina, Louis De Gama, Tania

A boutique filled with pretty items. Lots of colour and a very feminine selection.

Erickson Beamon

38 Elizabeth Street
London SW1 9NZ
020 7259 0202

Own label, Ziio

The most fabulous jewellery store in London.

Feathers

40 Hans Crescent
London SW1X 0LZ
020 7589 0356

Blumarine, Roberto Cavalli, Alessandro Dell'Aqua, Ermanno Scervino, John Richmond, Antonio Marras, Megan Park, Maria Grachvogel, Rozae Nichols

Been around for ever. Slightly mainstream in its buying, with a strong overseas clientele.

Iceblu

24 New Kings Road
London SW6 4AA
020 7371 9292

Fabrizio Lenzi, If Couture,
Chiasso, Marina Babini, Monica
Bianco, Montana, Nicki Juli,
Valentin

Tina's exclusive boutique only
stocks a label if it is not available
anywhere else in the UK. Buys
beautiful, classic, well-cut fabrics.

Joseph

77 Fulham Road
London SW3 6RE
020 7590 6200

Own label, Prada, Marni, Gucci,
Diane Von Furstenberg, John
Galliano, Clements Ribeiro,
Balenciaga

As well as own label, you will find
different pieces from Gucci and
Prada, among many others, here.

Matches

34 High Street
Wimbledon Village
London SW19 5BY
020 8947 8707

Chloe, Marc Jacobs, Prada,
Gucci, Earl Jean, Marni, Diane
Von Furstenberg

Great boutique with very honest
staff. You'll know how great or
terrible you really look.

Mimi

309 Kings Road
London SW3 5EP
020 7349 9699

Diane Von Furstenberg,
Clements Ribeiro, Roland Mouret,
Earl Jean, Alessandro Dell'Aqua,
Juicy Couture, Seven, Celine,
Katayone Adeli, Marc Jacobs,
Alberta Ferretti, Pucci, Missoni

As befits the owner of this store,
who is very well endowed, the
focus is for those with an
hourglass figure, from the
best bras and T-shirts to more
serious dressing. Ultimately
feminine.

London W

?Air

Westbourne Grove
London W11
020 7221 8163

Claudette, Vivienne Westwood,
Issey Miyake, Pleats Please,
Shirin Guild, Roberto Cavalli,
Betsey Johnson, Holly, Nuala,
Pringle, Orla Kiely, Rachel
Robarts, FrostFrench, Patrick
Cox, Hamnett, Joseph, Juicy
Couture, Seven, Maharishi, Paul
Smith

Extensive selection of great
labels. Offers huge range of
choices for any age, shape and
size. A wide selection in fab
locations in the southeast.

JW Beeton

48–50 Ledbury Road
London W11 2AJ
020 7229 8874

Fake, Boyd, Ann-Louise Roswald,
Custo, Rutzou, Quinto Colonna

Famed for eclectic individual
pieces that department stores
won't buy.

Browns

23–27 South Molton Street
London W1K 5QF
020 7514 0016

Jill Sander, Dries Van Noten,
Marni, D&G, Zoltan, John
Galliano, Missoni, Dosa

With such a regular clientele,
most key items from each season
are gone before they hit the
shop floor.

The Cross

141 Portland Road
London W11 4LR
020 7727 6760

Chloe, Dosa, Rozae Nichols,
Luisa Beccaria, Megan Park,
Ann-Louise Roswald, Missoni,
Vanessa Bruno, Fake, Gharani
Strok, Juicy Couture, Jamin
Puech, Anya Hindmarch, William
Welstead, Pippa Small

Sam and Sarah are the original
boutique owners of Notting Hill
and they still have the same feel
to their store. They buy as if they
are buying for themselves – they
both have to love it. Don't buy
with specific customers in mind.

Heidi Klein

174 Westbourne Grove
London W11 2RW
020 7243 5665

Melissa Odabash, TNA,
Saltwater, Calver & Wilson,
Lola Rose, Omak, Eref, Helen
Kaminski, La Slainas, Jonny
Loves Rosie, Orla Kiely, Cutler &
Gross, Chloe

Great new store that has bikinis to
make small tits larger and large
ones manageable. The one-stop
holiday shop for beachwear, and
a beauty.

Matches

60–64 Ledbury Road
London W11 2AJ
020 7722 7000

Chloe, Marc Jacobs, Prada,
Gucci, Earl Jean, Marni, Diane
Von Furstenberg

Great boutique with staff to
match. Tara is the most straight-
talking store manager in London.
You'll know how great or terrible
you really look.

Paul Smith

Westbourne House
122 Kensington Park Road
London W11 2EP

Own label, Jade Jagger

An innovatively designed
boutique in a grand converted
house just off Westbourne Grove.
Airy and relaxed, it is the perfect
place to view the full Paul Smith
collection.

Ruby Red

341 Portobello Road
London W10 5SA
020 8969 5051

Angela Tassoni, Lucy Goldman,
Samantha Salmons, Camilla
Dinesen, EX-OVO, Tufi, Tom
McEwan, Bark, Shakti

An interesting store that houses
new designers in the workshop
attached, allowing you to see
the progress on various pieces. A
great place to pick up unique
items and they are always happy
to take orders.

Shop

4 Brewer Street
London W1F 0SB
020 7437 1259

Cacharel, Marc Jacobs, Earl
Jean, Pringle, Silas

The owners of this boutique buy
with their ideal customer in mind,
which is the typical urban west-
end girl.

Sixty 6

66 Marylebone High Street
London W1 3AH
020 7224 6066

Megan Park, Jamin Puech, Day,
Alice Temperley, Velvet, Sixty 6
Cashmere, Atsuro Tayama, Paule
Ka, Antoni & Alison

High-quality individuality. Owner
Jane doesn't go along with the
look of each season; instead she
endorses investment buying.
Knows her customers so well she
will call them if an item of interest
comes in. Also stocks
a small selection of vintage
clothing and jewellery.

The West Village

35 Kensington Park Road
London W11 2EU
020 7243 6912

Own label, Jill Stewart jeans,
Mint, Jo Gordon, Orla Kiely,
Patch, Wnubb, Susan
Rosemary

Lucy, the owner, is a tall woman
and tends to buy for tall women.

Whistles

12 St Christopher's Place
London W1
020 7487 4484

Own Label, Rodolphe Menudier,
Dries Van Noten, Claudette,
Michael Stars, Earl Jean,
Martin Sitbon

Not strictly a boutique, as there
are many Whistles, but in some
stores (Kings Road, St
Christopher's Place and

directory

Brompton Cross) a good selection of casual/smart clothing.

Wilma

339 Portobello Road
London W10 5SA
020 8960 7296

Me&Ro, Mint, Ashish, FrostFrench, Lola, Bernstock & Spiers

A quirky, newish accessories store focusing on directional jewellery, bags, shoes and underwear.

London WC

?Air

38 Floral Street
London WC2E 9DG
020 7836 8220

Claudette, Vivienne Westwood, Issey Miyake, Pleats Please, Shirin Guild, Roberto Cavalli, Betsey Johnson, Holly, Nuala, Pringle, FrostFrench, Orla Kiely, Rachel Robarts, Patrick Cox, Hamnett, Joseph, Juicy Couture, Seven, Maharishi, Paul Smith

Extensive selection of great labels. Offers huge range of choices for any age, shape and size. A wide selection in fab locations in the southeast.

Koh Samui

65 Monmouth Street
London WC2H 9DG
020 7240 4280

One of the very first directional boutiques.

Manchester

Flannels

11 Police Street
Manchester M2 7LQ
0161 834 9442

Gucci, Prada, Etro, Alexander McQueen, Stella McCartney, Giorgio Armani, Joseph, Fake London, Evisu, Maharishi, D&G, Replay, Fendi, Juicy Couture, Plein Sud, Jimmy Choo, Burberry, Voyage

Excellent choice of high-fashion designers. A chain of well-stocked

boutiques in many locations outside London.

Oyster

1 Booth Street
Pall Mall
Manchester M2 4DU
0161 839 7575

Matthew Williamson, Fake London, FrostFrench, Juicy Couture, Emily Shoehorn

Clare and Caroline stock their boutique with items that they love. A fairly new store already building a loyal customer base.

Newcastle

Cruise

1–6 Princess Square
Newcastle NE1 8ER
0191 261 0510

Burberry, Prada, Prada Sport, D&G, Barbara Bui, Cavalli, Hugo Boss Women, Paul Smith Women, Chloe, Joseph, Earl Jean, D&G Jeans, Duffer, APC, Antoni & Alison, Alexander McQueen, Replay, Temperley, Giorgio Armani Collezioni

Provides a wide range of styles, from funky street wear to elegant evening attire. A well-stocked boutique in key locations in the North.

Norfolk

Anna

Market Place
Burnham Market
Kings Lynn
Norfolk PE31 8HE
01328 730 325

Nicole Farhi, Orla Kiely, Rutzou, Saltwater, Ann-Louise Roswald, Maharishi, Red Hot, Holly, Tania, Alice Temperley, Velvet, Designers Remix

A boutique that doesn't follow trends but provides wearable feminine clothes that will not date. Classics with the quirky thrown in for good measure. Anna keeps an eye on up-and-coming designers, both British and European.

Catherine Barclay

4 St Gregory's Alley
Norwich
Norfolk NR2 1ER
01603 626 751

Paul Smith, Ghost, Nicole Farhi, Earl Jean, Fake London, Anonymous, Sara Berman, Margaret Howell, Shirin Guild, Joseph, L.K. Bennett

Catherine was previously a personal dresser and fashion buyer and the philosophy of her store reflects this. She has a very good knowledge of her clients and their lifestyles, and this helps her provide them with exactly what they want. A personal shopping boutique.

Nottingham

Flannels

34–36 Bridlesmith Gate
Nottingham NG1 2GQ
0115 947 6466

Gucci, Prada, Alexander McQueen, Stella McCartney, Etro, Giorgio Armani, Joseph, Fake London, Evisu, Maharishi, Replay, Fendi, Juicy Couture, Jimmy Choo, Burberry, Voyage, D&G, Plein Sud

Excellent choice of high-fashion designers. A chain of well-stocked boutiques in many locations in the North.

Milli

The Frontage
Queen Street
Nottingham NG1 2BL
0115 950 2882

Marni, Miu Miu, Paul Smith, Chloe, Philosophy di Alberta Ferretti, Burberry, Sergio Rossi, Fake Junior, Maharishi, Buddhist Punk, Day, D&G, Hands, Velvet, J&M Davidson

Contemporary choice, very feminine and sexy influences.

Oxford

Vanilla

13 South Parade
Oxford OX2 7JN
01865 552 155

Cacharel, Maharishi, Earl Jean, Bruns Bazar, John Medley, Velvet, Ann-Louise Roswald, L.K. Bennett, Vanessa Bruno, Pebble, Betsey Johnson, Lilith, Transit

Prides itself on being the only store to provide Oxford with such labels. Has a very loyal customer base and buys with them in mind. The place to go if you are out of town and want that something extra.

Suffolk

Anna

7 Guildhall Street
Bury St Edmunds
Suffolk IP33 1PR
01284 706 944

Nicole Farhi, Orla Kiely, Rutzou, Saltwater, Ann-Louise Roswald, Maharishi, Red Hot, Holly, Tania, Alice Temperley, Velvet, Designers Remix

A boutique that doesn't follow trends but provides wearable feminine clothes that will not date. Classics with the quirky thrown in for good measure. The owner, Anna, keeps an eye on up-and-coming designers.

Surrey

Bernards

4–6 High Street
Esher
Surrey KT10 9RT
01372 468 032

Sara Berman, Gharani Strok, Boyd, Matthew Williamson, Juicy Couture, See by Chloe, Ben di Lisi, Giorgio Armani Collezioni, Jorando

Buy the extreme but still wearable pieces from each collection; the owner has to have a passion for each piece.

directory

Courtyard

5–6 Angel Gate
Guildford
Surrey GU1 4AE
01483 452 825

Artwork, Betsey Johnson, C.P. Company, Earl Jean, Fleur T, Gharani Strok, Gina, Joseph, Juicy Couture, Marilyn Moore, Matthew Williamson, Megan Park, Paul Smith, Preston Knight, Pringle, Rachel Robarts, Roland Mouret, Streets Ahead, Ronit Zilkha, Scott Henshall, Sonia Rykiel, Velvet, Voyage Passion, Love Sex Money

The more unusual, special pieces from the collections, concentrating on beautiful fabrics and quality. The more casual dresser is also catered for in depth, with a great choice of knitwear, jeans and T-shirts. Cover a wide price and age range and try to give customers something new each month.

Footlights

21 Oakdene Parade
Cobham
Surrey KT11 2LG
01932 860 190

D&G Jeans, D&G, DKNY, Cerrutti, Frankie B, Jane Norris, Betsey Johnson, Kenzo, Jasper Knits, Twinset, Roberta Scarpa, Rachel Robarts, Blumarine, Belinda Robertson Cashmere

The shop has a funky style. The owners buy from the middle to higher end of collections and choose a wide variety of styles. Buy with customers in mind.

Lucy's

6 York Road
Weybridge
Surrey KT13 9DT
01932 847 939

Ralph Lauren, Joseph, Whistles, MPL Cashmere, Ballantyne Cashmere

Owner Lucy invests in an eclectic mix, including classics for day and evening teamed with decorative seasonal separates. Enjoys a loyal customer base and provides a friendly service.

Warwickshire

The Dresser

9 Old Red Lion Court
Stratford Upon Avon
Warwickshire CV37 6AB
01789 296 517

Margaret Howell, Betty Jackson, Betsey Johnson, Artwork, Mr and Mrs MacLeod, Marilyn Moore, Sara Berman

Feminine feeling with a wide choice of eye-catching pieces, teamed with wearability.

East Yorkshire

Riley's

11 Northbar Within
Beverley
East Yorkshire HU17 8AP
01482 868 903

D&G, Nicole Farhi, Roberto Cavalli, Transit, Luc Berjen, Fake London, Fake Genius, Joseph

Many customers of this boutique entrust their entire wardrobe to the owners, who will ensure that you'll never look the same as your friends.

North Yorkshire

Morgan Clare

3 Montpellier Gardens
Harrogate
North Yorkshire HG1 2TF
01423 565 709

Angela Hale, Anne Storey, Vallantyne, Boyd, Fred Bare, Georgina Von Etzdorf, Joseph, L.K. Bennett, Orla Kiely, Osprey, Paul Smith, Saltwater, Whistles, Mr and Mrs MacLeod, N Peal, Shirin Guild, Darren Hall, Maharishi

Stock a massive range of lots of different designers so can accommodate all ages and all occasions. Like to buy a wide selection from the extreme to the wearable end of collections.

Designers and which stores carry them

Alberta Ferretti

London
Harrods
020 7730 1234
Mimi
020 349 9699

Kent (Tunbridge Wells)
The Changing Room
01892 547 899

Nottingham
Milli
0115 950 2882

Alexander McQueen

London
Selfridges
020 7629 1234

Bath
Square
01225 464 997

Birmingham
Flannels
0121 633 4154

Manchester
Flannels
0161 834 9442

Nottingham
Flannels
0115 947 6466

Alice Temperley

London
A la Mode
020 7730 7180
Anna
020 7483 0411
JW Beeton
020 7229 8874
Browns
020 7514 0016
Harrods
020 7730 1234

Cambridge
Hero
01223 328 740

Edinburgh
Cruise
0131 220 4441

Glasgow
Cruise
0141 572 3232

Newcastle
Cruise
0191 261 0510

Norfolk (Kings Lynn)
Anna
01328 730 325
Suffolk (Bury St Edmunds)
Anna
01284 706 944

Amanda Wakeley

Hampshire (Alresford)
Moda Rosa
01962 733 277
Nationwide
House of Fraser
020 7963 2000

Anna Molinari

Bath
Square
01255 464 997
Nationwide
House of Fraser
020 7963 2000

Ann-Louise Roswald

London
The Cross
020 7727 6760
Sublime
020 8986 7243
Norfolk (Kings Lynn)
Anna
01328 730 325
Oxford
Vanilla
01865 552 155
Suffolk (Bury St Edmunds)
Anna
01284 706 944

Balenciaga

London
Joseph
020 7590 6200
Liberty
020 7734 1234

Ben di Lisi

London
Fenwick
020 7629 9161
Birmingham (Solihull)
Katherine Draisey
0121 704 2233

Hampshire (Alresford)
Moda Rosa
01962 733 277
Surrey (Esher)
Bernards
01372 468 032

Betsey Johnson

London
?Air
020 7221 8163
Fenwick
020 7629 9161
Birmingham (Solihull)
Katherine Draisey
0121 704 2233
Essex (Chelmsford)
Blue Lawn
01245 250 083
Hampshire (Alresford)
Moda Rosa
01962 733 277
Surrey (Cobham)
Footlights
01932 860 190
Surrey (Guildford)
Courtyard
01483 452 825
**Warwickshire
(Stratford Upon Avon)**
The Dresser
01789 296 517

Betty Jackson

London
Fenwick
020 7629 9161
Selfridges
020 7629 1234

Blumarine

London
A la Mode
020 7730 7180
Feathers
020 7589 0356
Bath
Square
01225 464 997
Cheshire (Wilmslow)
Garbo
01625 521 212
Surrey (Cobham)
Footlights
01932 860 190

Burberry

London
Selfridges
020 7620 1234
Bath
Square
01255 464 997
Birmingham
Flannels
0121 633 4154
Cambridge
Giulio
01223 423 776
Cheshire (Wilmslow)
Garbo
01625 521 212
Edinburgh
Cruise
0131 220 4441
Leeds
Strand
0113 243 8164
Liverpool
Wade Smith
0151 255 1077
Manchester
Flannels
0161 834 9442
Newcastle
Cruise
0191 261 0510
Nottingham
Milli
0115 950 2882

Cacharel

London
A la Mode
020 7730 7180
Liberty
020 7734 1234
Birmingham (Solihull)
Katherine Draisey
0121 704 2233
Essex (Buckhurst Hill)
Shop 77
020 8505 5111
Liverpool
Cricket
0151 227 4645
Oxford
Vanilla
01865 552 155

Calvin Klein

London
Harrods
020 7730 1234
House of Fraser
020 7963 2000
Edinburgh
Cruise
0131 220 4441
Newcastle
Cruise
0191 261 0510

Catherine Malandrino

London
Fenwick
020 7629 9161
Harrods
020 7730 1234

Celine

London
Harrods
020 7730 1234
Mimi
020 7349 9969

Chloe

London
A la Mode
020 7730 7180
Club 21
020 7761 8888
The Cross
020 7727 6760
Designer Club
020 7235 2245
Hannah Lee
020 7586 4121
Harvey Nichols
020 7235 5000
Matches
020 7722 7000
Selfridges
020 7629 1234
Shop
020 7437 1259
Bath
Square
01225 464 997
Cheshire (Wilmslow)
Garbo
01625 521 212

Edinburgh
Cruise
0131 220 4441
Essex (Chelmsford)
Blue Lawn
01245 250 083
Kent (Tunbridge Wells)
The Changing Room
01892 547 899
Leeds
Strand
0113 243 8164
Liverpool
Cricket
0151 227 4645
Newcastle
Cruise
0191 261 0510
Nottingham
Milli
0115 950 2882
Surrey (Esher)
Bernards
01372 464 604

Clements Ribeiro

London
Browns
020 7514 0016
Harvey Nichols
020 7235 5000
Joseph
020 7590 6200
Liberty
020 7734 1234
Matches
020 7722 7000
Mimi
020 7349 9969
Selfridges
020 7629 1234
Bath
Square
01255 464 997
Hampshire (Alresford)
Moda Rosa
01962 733 277
Kent (Tunbridge Wells)
The Changing Room
01892 547 899
North Yorkshire (Harrogate)
Morgan Clare
01423 565 709

Collette Dinnigan

London
Harrods
020 7730 1234
Harvey Nichols
020 7235 5000
Koh Samui
020 7240 4280
Mimi
020 7349 9699
Bath
Jaq
01255 447 975

Cerruti

London
Selfridges
020 7629 1234
Surrey (Cobham)
Footlights
01932 860 190

DKNY

London
Harrods
020 7730 1234
House of Fraser
020 7963 2000
Selfridges
020 7629 1234
Cambridge
Giulio
01223 328 740
Essex (Chelmsford)
Blue Lawn
01245 250 083
Exeter
Willy's
01392 256 070
Surrey (Cobham)
Footlights
01932 860 190

Dolce & Gabbana

London
Browns
020 7514 0016
Harrods
020 7730 1234
Harvey Nichols
020 7235 5000
Selfridges
020 7629 1234

Bath
Square
01225 464 997
Edinburgh
Cruise
0131 220 4441
Essex (Buckhurst Hill)
Shop 77
020 8505 5111
Exeter
Willy's
01392 256 070
Leeds
Strand
0113 243 8164
Liverpool
Wade Smith
0151 255 1077
Newcastle
Cruise
0191 261 0510
Surrey (Cobham)
Footlights
01932 860 190
East Yorkshire (Beverley)
Riley's
01482 868 903

Donna Karan

Hampshire (Alresford)
Moda Rosa
01962 733 277

Dries Van Noten

London
Browns
020 7514 0016
The Cross
020 7727 6760
Harvey Nichols
020 7235 5000
Liberty
020 7734 1234
Whistles
020 7487 4484

Earl Jean

Harvey Nichols
020 7235 5000
House of Fraser
020 7963 2000
Matches
020 7722 7000
Shop
020 7437 1259

Whistles
020 7487 4484
Bath
Square
01225 464 997
Cambridge
Giulio
01223 423 776
Edinburgh
Cruise
0131 220 4441
Glasgow
Cruise
0141 572 3232
Newcastle
Cruise
0191 261 0510
Norfolk (Norwich)
Catherine Barclay
01603 626 751
Oxford
Vanilla
01865 552 155
Surrey (Guildford)
Courtyard
01483 452 825

Elspeth Gibson

London
Selfridges
020 7629 1234

Emmanuel Ungaro

London
A la Mode
020 7730 7180
Bath
Square
01225 464 997
Birmingham
Flannels
0121 633 4154
Bournemouth
Richmond Classics
01202 295 298
Brighton
Mottoo
01273 326 633
Cambridge
Giulio
01223 423 776
Cheshire (Wilmslow)
Garbo
01625 521 212

Edinburgh
Corniche
0131 556 3707
Essex (Chelmsford)
Blue Lawn
01245 250 083
Glasgow
Cruise
0141 572 3232
Lancashire (Barrowford)
Velvet
01282 699 797
Leeds
Strand
01132 438 164
Manchester
Flannels
0161 834 9442
Oyster
0161 839 7575
Norfolk (Norwich)
Catherine Barclay
01603 626 751
Nottingham
Flannels
01159 476 466
East Yorkshire (Beverley)
Rileys
01482 868 903

Fornarina
London
EG Butterfly
020 7371 9291
Gotham Angels
020 7359 8090
Cambridge
Hero
01223 328 740

FrostFrench
London
?Air
020 7221 8163
Wilma
020 8960 7296
Exeter
Willy's
01392 256 070
Liverpool
Cricket
0151 227 4645
Manchester
Oyster
0161 839 7575

Gharani Strok
London
The Cross
020 7727 6760
Linea
020 7794 1775
Cheshire (Wilmslow)
Garbo
01625 521 212
Surrey (Esher)
Bernards
01372 464 604

Ghost
London
Hannah Lee
020 7586 4121
Liberty
020 7734 1234
Selfridges
020 7629 1234
Bath
Square
01225 464 997
Cambridge
Hero
01223 328 740
Essex (Chelmsford)
Blue Lawn
01245 250 083
Norfolk (Norwich)
Catherine Barclay
01603 626 751
Surrey (Guildford)
Courtyard
01483 452 825
North Yorkshire (Harrogate)
Morgan Clare
01423 565 709

Gina
London
Gina
020 7235 2932
Bath
Jaq
01225 447 975
Cheshire (Wilmslow)
Garbo
01625 521 212
Hampshire (Alresford)
Moda Rosa
01962 733 277

Giorgio Armani
London
Fenwick
020 7629 9161
Selfridges
020 7629 1234
Birmingham
Flannels
0121 634 154
Edinburgh
Cruise
0131 220 4441
Glasgow
Cruise
0141 572 3232
Manchester
Flannels
0161 834 9442
Newcastle
Cruise
0191 261 0510
Nottingham
Flannels
0115 947 6466
Surrey (Esher)
Bernards
01372 468 032

Gucci
London
Harrods
020 7730 1234
Matches
020 7722 7000
Bath
Square
01225 464 997
Cambridge
Giulio
01223 423 776
Liverpool
Wade Smith
0151 255 1077

J&M Davidson
London
Harrods
020 7730 1234
Harvey Nichols
020 7235 5000
Selfridges
020 7629 1234

**Warwickshire
(Stratford Upon Avon)**
The Dresser
01789 296 517

Jamin Puech
London
The Cross
020 7727 6760
Fenwick
020 7629 9161
Liberty
020 7734 1234
Sixty 6
020 7224 6066

John Galliano
London
A la Mode
020 7730 7180ï
Browns
020 7514 0016
Designer Club
020 7235 2242
Harrods
020 7730 1234
Joseph
020 7590 6200

Joseph
London
Own store
020 7590 6200
House of Fraser
020 7963 2000
Bath
Square
01225 464 997
Cambridge
Hero
01223 328 740
Edinburgh
Cruise
0131 220 4441
Glasgow
Cruise
0141 572 3232
Newcastle
Cruise
0191 261 0510
Norfolk (Norwich)
Catherine Barclay
01603 626 751

directory

Surrey (Guildford)
Courtyard
01483 452 825
East Yorkshire (Beverley)
Riley's
01482 868 903
North Yorkshire (Harrogate)
Morgan Clare
01423 565 709

Juicy Couture
London
The Cross
020 7727 6760
Mimi
020 7349 9699
Birmingham
Flannels
0121 633 4154
Cheshire (Wilmslow)
Garbo
01625 521 212
Essex
Shop 77
0208 505 5111
Exeter
Willy's
01392 256 010
Liverpool
Cricket
0151 227 4645
Manchester
Flannels
0161 834 9442
Oyster
0161 839 7575
Nottingham
Flannels
0115 947 6466
Surrey (Esher)
Bernards
01372 464 604
Surrey (Guildford)
Courtyard
01483 452 825

La Perla
London
Own store
020 7245 0527
Harrods
020 7730 1234
Selfridges
020 7629 1234

Birmingham (Solihull)
Katherine Draisey
0121 704 2233
Cheshire (Wilmslow)
Garbo
01625 521 212

Marc Jacobs
London
A la Mode
020 7730 7180
Fenwick
020 7629 9161
Harvey Nichols
020 7235 5000
Joseph
020 7590 6200
Matches
020 7722 7000
Mimi
020 7349 9699
Liverpool
Cricket
0151 227 4645

Maria Grachvogel
London
Feathers
020 7589 0356
North Yorkshire (Harrogate)
Morgan Clare
01423 565 709

Marni
London
Own store
020 7235 1911
A la Mode
020 7730 7180
Browns
020 7514 0016
Harrods
020 7730 1234
Joseph
020 7590 6200
Matches
020 7722 7000
Bath
Square
01225 464 997
Nottingham
Milli
0115 950 2882

Martin Kidman
London
Matches
020 7722 7000

Matthew Williamson
Bath
Square
01225 464 997
Birmingham (Solihull)
Katherine Draisey
0121 704 2233
Cheshire (Wilmslow)
Garbo
01625 521 212
Hampshire (Alresford)
Moda Rosa
01962 733 277
Liverpool
Cricket
0151 227 4645
Manchester
Oyster
0161 839 7575
Surrey (Esher)
Bernards
01372 468 032
Surrey (Guildford)
Courtyard
01483 452 825

Megan Park
London
The Cross
020 7727 6760
Feathers
020 7589 0356
Sixty 6
020 7224 6066
Bath
Jaq
01225 447 975

Michael Kors
London
Harrods
020 7730 1234
Harvey Nichols
020 7235 5000
Bath
Jaq
01225 447 975

Michael Stars
London
Whistles
020 7487 4484
Essex (Buckhurst Hill)
Shop 77
020 8505 5111

Missoni
London
Ajanta
020 7235 1572
Browns
020 7514 0016
The Cross
020 7727 6760
Fenwick
020 7629 9161
Harrods
020 7730 1234
Harvey Nichols
020 7235 5000
Linea
020 7794 1775
Mimi
020 7349 9699
Birmingham
Harvey Nichols
0121 616 6000
Cheshire (Wilmslow)
Garbo
01625 521 212
Hampshire (Alresford)
Moda Rosa
01962 733 277
Leeds
Harvey Nichols
0113 204 8888
Liverpool
Cricket
0151 227 4645

Mulberry
London
Own store
020 7491 3900

Nicole Farhi
London
Own store
020 7499 8368
Fenwick
020 7629 9161
House of Fraser
020 7963 2000

Norfolk (Norwich)
Catherine Barclay
01603 626 751
East Yorkshire (Beverley)
Riley's
01482 868 903

Nuala

London
?Air
020 7221 8163
Harvey Nichols
020 7235 5000
Selfridges
020 7629 1234
Sweaty Betty
0800 169 3889

Orla Kiely

London
?Air
020 7221 8163
Anna
020 7483 0411
Hannah Lee
020 7586 4121
Harrods
020 7730 1234
Heidi Klein
020 7243 5665
Selfridges
020 7629 1234
The West Village
020 7243 6912
Norfolk (Kings Lynn)
Anna
01328 730 325
Suffolk (Bury St Edmunds)
Anna
01284 706 944
**Warwickshire
(Stratford Upon Avon)**
The Dresser
01789 296 517

Paul Smith

London
Hannah Lee
020 7586 4121
Birmingham (Solihull)
Katherine Draisey
0121 704 2233
Cambridge
Giulio
01223 328 740

Edinburgh
Cruise
0131 220 4441
Exeter
Willy's
01392 256 070
Essex (Chelmsford)
Blue Lawn
01245 250 083
Glasgow
Cruise
0141 572 3232
Kent (Tunbridge Wells)
The Changing Room
01892 547 899
Leeds
Strand
0113 243 8164
Liverpool
Wade Smith
0151 255 1077
Newcastle
Cruise
0191 261 0510
Norfolk (Norwich)
Catherine Barclay
01603 626 751
Nottingham
Milli
0115 950 2882
Surrey (Guildford)
Courtyard
01483 452 825
North Yorkshire (Harrogate)
Morgan Clare
01423 565 709

Plein Sud

London
Hannah Lee
020 7586 4121
House of Fraser
020 7963 2000
Birmingham
Flannels
0121 633 4154
Cheshire (Wilmslow)
Garbo
01625 521 212
Essex (Buckhurst Hill)
Shop 77
020 8505 5111
Manchester
Flannels
0161 839 7575

Nottingham
Flannels
0115 947 4666

Prada

London
Own store
020 7235 0008
Joseph
020 7590 6200
Matches
020 7722 7000
Birmingham
Flannels
0121 633 4154
Cambridge
Giulio
01223 423 776
Edinburgh
Cruise
0131 220 4441
Glasgow
Cruise
0141 572 3232
Liverpool
Wade Smith
0151 255 1077
Manchester
Flannels
0161 834 9442
Newcastle
Cruise
0191 261 0510
Nottingham
Flannels
0115 947 6466

Pringle

London
?Air
020 7221 8163
House of Fraser
020 7963 2000
Liberty
020 7734 1234
Selfridges
020 7629 1234
Shop
020 7437 1259
Cambridge
Giulio
01223 423 776

Pucci

London
Browns
020 7514 0016
Mimi
020 7349 9699

Rachel Robarts

London
?Air
020 7221 8163
EG Butterfly
020 7371 9291
Surrey (Guildford)
Courtyard
01483 452 825

Roberto Cavalli

London
?Air
020 7221 8163
Club 21
020 7235 2242
Feathers
020 7589 0356
Edinburgh
Cruise
0131 220 4441
Glasgow
Cruise
0141 572 3232
Newcastle
Cruise
0191 261 0510
East Yorkshire (Beverley)
Riley's
01482 868 903

Ronit Zilkha

London
Harvey Nichols
020 7235 5000
House of Fraser
020 7963 2000
Selfridges
020 7629 1234
Surrey (Guildford)
Courtyard
01483 452 825

Rozae Nichols

London
The Cross
020 7727 6760

Feathers
020 7589 0356
Harvey Nichols
020 7235 5000

Saltwater

London
Anna
020 7483 0411
Heidi Klein
020 7243 5665
Liberty
020 7734 1234
Mimi
020 7349 9699
Sublime
020 8986 7243
North Yorkshire (Harrogate)
Morgan Clare
01423 565 709

Sara Berman

London
Fenwick
020 7629 9161
Liberty
020 7734 1234
Sublime
020 8986 7243
Norfolk (Norwich)
Catherine Barclay
01603 626 751
Surrey (Esher)
Bernards
01372 468 032
**Warwickshire
(Stratford Upon Avon)**
The Dresser
01789 296 517

Seven Jeans

London
?Air
020 7221 8163
Mimi
020 7349 9699
Essex (Buckhurst Hill)
Shop 77
020 8505 5111

Shirin Guild

London
Liberty
020 7734 1234

Cambridge
Hero
01223 328 740
Norfolk (Norwich)
Catherine Barclay
01603 626 751

Sophia Kokosalaki

London
Liberty
020 7734 1234
Bath
Jaq
01225 447 975

Stella McCartney

London
A la Mode
020 7730 7180
Harvey Nichols
020 7235 5000
Birmingham
Flannels
0121 633 4154
Leeds
Strand
0113 438 164
Liverpool
Cricket
0151 227 4645
Manchester
Flannels
0161 834 9442
Nottingham
Flannels
0115 947 6466

Sybil Stanislaus

London
Ajanta
020 7235 1572

Vanessa Bruno

London
The Cross
020 7727 6760

Velvet

London
Anna
020 7483 0411
JW Beeton
020 7229 8874

Cambridge
Giulio
01223 423 776
Norfolk (Kings Lynn)
Anna
01328 730 325
Suffolk (Bury St Edmunds)
Anna
01284 706 944

Voyage

Birmingham
Flannels
0121 633 4154
Cambridge
Hero
01223 328 740
Manchester
Flannels
0161 834 9442
Nottingham
Flannels
0115 947 6466

Major department stores around the country

Although most department stores carry the same basic labels, the flagship stores will tend to carry all mentioned. It is worth telephoning beforehand to check that the labels are still carried.

Debenhams

Flagship Store
London
020 7580 3000
Branches nationwide

Ben de Lisi, Antoni & Alison, Maria Grachvogel, Gharani Strok, Jasper Conran, John Richmond, John Rocha, Whistles

Fenwick

Flagship Store
London
020 7629 9161

Other Stores
Brent Cross
020 8202 8200
Canterbury
01227 766 866
Leicester
0116 255 3322
Newcastle
0191 232 5100
Tunbridge Wells
01892 516 716
Windsor
01753 855 537
York
01904 643 322

Anna Sui, John Rocha, Betty Jackson, Sportmax, Sara Berman, Paul Smith, Betsey Johnson, Catherine Malandrino, Rebecca Taylor, Alannah Hill, Nicole Farhi, Ben de Lisi, Amaya Arzuaga, Lezley George
Young Labels
Chine, Plenty, Stella Cadente, Calypso, Orla Kiely, Paul&Joe ABS, Seven Jeans, Marrika Nakk, Max & Co, Tara Jarmon, Sarah King, Bella Dahl, Replay, Velvet
Classic Labels
Giorgio Armani Collezioni, Ischiko, Kenzo Jungle, Patrizia Pepe, Marella, Gerard Darel, Caractere, Fenn Wright Manson, Renato Nucci, John Smedley
Accessories
Missoni, Marc Jacobs, Jamin Puech, Bill Amberg, Ally Capellino, Joomi Joolz, Noir, Antik Batik, Orla Kiely, Paul Smith,

Streets Ahead, Philip Treacy, Fred Bare

Harrods

London
020 7730 1234

Alberta Ferretti, Celine, Chanel, Issey Miyake, Jill Sander, John Galliano, Jean Paul Gaultier, Julian McDonald, Missoni, Michael Kors, Prada, Rebecca Moses, Yohji Yamamoto, Burberry, Christian Dior, Calvin Klein, DK Signature, Gucci, D&G, Moschino, Marni, Yves Saint Laurent

Harvey Nichols

London
020 7235 5000
Birmingham
0121 616 6000
Edinburgh
Opening Sep 2002
Leeds
0113 204 8888

London
Celine, Marc Jacobs, Dries Van Noten, Chloe, Donna Karen, Ralph Lauren, Marc by Marc Jacobs, Cacharel, Leonard, Miu Miu, Earl Jean, Seven Jeans, Juicy Couture
Birmingham
YSL, Rive Gauche, Gucci, D&G, Chloe, Marc Jacobs, Earl Jean, Juicy Couture, Donna Karen, Giorgio Armani Collezioni
Leeds
Christian Dior, Celine, YSL Rive Gauche, Gucci, D&G, Chloe, Marc Jacobs, Earl Jean, Seven Jeans, Juicy Couture, Donna Karen, Giorgio Armani Collezioni

House of Fraser

Flagship Stores
Army & Navy
London
020 7834 1234
Barkers
London
020 7937 5432
Dickens & Jones
London

020 7734 7070
Branches nationwide

Jacques V, Liz Claiborne, Betty Barclay, Austin Reed, Alexon, Aquascutum, Eastex, Windsmoor, Dash, Viyella, Jaegar, Country Casuals, Nitya, Feraud
Classics
John Smedley, Hobbs, Episode, Consortium, Amanda Wakeley, Caractere, Fenn Wright Manson, Kaliko, E'Sensual, Cashmere, P Costello, Wallis, Planet, Frank Usher, Priciples, Ronit Zilkha, Pringle
Smart
Oasis, Warehouse, Elle, Whistles, Morgan, Jesire, Kookai, Vicky Mart, Miss Selfridge, Karen Millen, AN GE, Reiss, Coast, Giant, Ted Baker, Press & Bastyan
Fashion Lover
DKNY Jeans, Joseph, CK Jeans, Earl Jean, Paul Smith Jeans, See by Chloe, New York Industry, Ted Baker, Sportmax Code, D&G Jeans, Moschino Jeans, Custo Barcelona, Nougat, Turnover, Tommy Hilfiger, Peter Golding, Great Plains, DKNY, Armani Jeans, Ghost, Farhi, 120% Linen, Oska, Pringle, Plein Sud, Roberto Cavalli, Iceberg Jeans, Kenzo, Ischiko, Annette Gortz, Joyce Ridings, Betty Jackson, Paper Denim Cloth

Liberty

London
020 7734 1234

Joseph, Cacharel, Paul Smith, Vivienne Westwood, Chine, Sara Berman, Eley Kishimoto, Bernard Willhelm, Blaak, Sophia Kokosalaki, Costume National, John Smedley, For Design Sake, Earl Jean, Pringle, Martin Margiela 6, Maharishi, Juicy Couture, Toilette, Custo, Armani, Dries Van Noten, Issey Miyake, Pleats Please, Chloe, Balenciaga, Ann Demeulemeester, Helmut Lang, Yohji Yamamoto, Windcoat, Marithé François Girbaud, Shirin Guild, Annette Gortz, Antonio

Marras, Oska, Ishiko, Betty Jackson, Jennifer Dagworthy, Mr and Mrs MacLeod, Paddy Campbell, Ghost, Charles and Patricia Lester, Zandra Rhodes, Saverio Palatella, Razu Mikhina

Selfridges

London
020 7629 1234

Alexander McQueen, Alessandro Dell'Aqua, Ann Demeulemeester, Annette Gortz, Antonio Berardi,Giorgio Armani Collezioni, Bazar, Betty Jackson, Burberry, Cerruti, Chloe, Clements Ribeiro, Comme des Garçons, DKNY, D&G, Elspeth Gibson, Exte, Fendi, Ghost, Helmut Lang, Hugo Boss, Iceberg, Ischiko, Jasper Conran, Julien McDonald, Junya Watanabe, Kenzo Jungle, Kenzo Paris, Laundry Industry, Laurel, Lawrence Steele, Lezley George, Marcus Lupfer, Margaret Howell, Martin Margiela 1, Martin Margiela 6

Designers' own label stores in London

Alberta Ferretti

205–206 Sloane Street
London SW1
020 7235 2349

Staff allow you to browse for a long time before thinking to come up and disturb you.

Alexander McQueen

47 Conduit Street
London W1
020 7734 2340

Very cool, trendy staff – but once you show a passion for his clothes they go out of their way to help.

Anna Molinari

11a Old Bond Street
London W1
020 7408 9892

Shop on two floors and if you go to the basement the staff scuttle down and pounce.

Burberry

21–23 New Bond Street
London W1
020 7968 0000

Popular with tourists. The staff can be impatient in dealing with customers. Don't know the stock very well on the ground floor.

Butler and Wilson

20 South Molton Street
London W1K 5QY
020 7409 2955

Two great stores in London, both with extremely helpful staff.

Chanel

167–170 Sloane Street
London SW1X
020 7235 6631

With their over made-up faces it is easy to want to walk straight out. The clothes on the catwalk always appear younger than their store counterparts – you have to try them on to see the difference.

Christian Dior

31 Sloane Street
London SW1
020 7235 1357

Used to the international clients of Sloane Street, this store can be quite intimidating.

Christian Louboutin

23 Motcomb Street
London SW1
020 7823 2234

Small store with two great owners, Sarah and Andreas, who share a passion for the designer.

Collette Dinnigan

26 Cale Street
Chelsea Green
London SW3
020 7589 8897

Dolce & Gabbana

6–8 Old Bond Street
London W1
020 7659 9000

Great store to look at. Staff quite intimidating, unless you look like you have money to spend.

Elspeth Gibson

7 Pont Street
London SW1
020 7235 0601

Charming girls.

Gina

189 Sloane Street
London SW1
020 7235 2932

Spend quite a lot of time chatting behind the till; maybe they think the shoes can speak for themselves.

Giorgio Armani

37 Sloane Street
London SW1
020 7235 6232

The shop has the feel of the type of church you have to whisper in, and the staff are rather funereal, but like priests, they are better once they engage in conversation.

Gucci

18 Sloane Street
London SW1
020 7235 6707

The security guards could put you off going in, but don't be fazed – the staff are suprisingly warm and friendly.

Hermes

155 New Bond Street
London W1
020 7823 1014

A mixture: the French can be snobby, the Japanese look after their own, and that doesn't leave many to help.

J&M Davidson

42 Ledbury Road
London W11
020 7313 9532

Very friendly girls who epitomise the laid-back Notting Hill vibe.

Jane Brown

189 Westbourne Grove
London W11
020 7229 7999

Will do special orders, nothing too much trouble, great shoes.

Joseph

26 Sloane Street
London SW1
020 7235 5470

Varies from store to store, but staff well trained and will offer to call other stores to find what you need.

Liza Bruce

9 Pont Street
London
SW1X 9EJ
020 7235 8423

A buzzer door entry policy might put off the nervous, the bikinis are for the best figures and the changing room lighting will even stop Elle Macpherson from feeling good about her body.

Louis Vuitton

17–18 New Bond Street
London W1
020 7399 4050

It's always the same; take a store with more tourists than local customers and the locals feel let down by the disdainful and cold service.

Manolo Blahnik

49–51 Old Church Street
London SW3
020 7352 8622

Considering this must be the Mecca of shoe shops in London, the staff are surprisingly charming and helpful.

Marni

16 Sloane Street
London SW1
020 7235 1991

Check out the sales assistants to see how to put together the 'Marni' look.

Miu Miu

123 New Bond Street
London W1
020 7409 0900

Delightful staff who wear the label very well and will call around Europe to find the right sizes.

Mulberry

41–42 New Bond Street
London W1
020 7491 3900

Very charming and helpful.

Prada

43–45 Sloane Street
London SW1
020 7235 0008

Once you have the attention of the staff they will search out stock for you. The store is generally busy on a Saturday and you can expect to queue for up to 15 minutes to pay.

Ralph Lauren

1 New Bond Street
London W1
020 7535 4600

Efficient and US-trained staff who go out of their way to help.

Roberto Cavalli at Club 21

9 West Halkin Street
London SW1
020 7235 2242

Not one English sales assistant shows that their clientele speak many languages. Ultimate Eurotrash shop.

Sergio Rossi

12 Beauchamp Place
London SW1
020 7235 0663

Great shoes, small shop, OK staff.

Stephan Kelian

48 Sloane Street
London
SW1X 9LU
020 7235 9459

The rudest girls on Sloane Street. But the best boots for thick calves, so don't engage – just buy and leave.

Tod's

35 Sloane Street
London SW1
020 7235 1321

Tod's has gone through a major revival and due to demand the staff have become slightly blasé.

Valentino

174 Sloane Street
London SW1
020 7235 5855

For such an expensive store, with a grand entrance, the staff are very helpful.

Versace

34 Old Bond Street
London W1
020 7499 1862

This store has many celebrity clients and if you show attitude they will be helpful in case you are someone famous.

Vivienne Westwood

44 Conduit Street
London W1S 2YL
020 7439 1109

Very cool shop with clothes cut to perfection but not always easy to understand. Some days the staff are there to interpret, other times they expect the client to be an expert.

Yves Saint Laurent

171–172 Sloane Street
London SW1
020 7235 6706

Very helpful staff.

directory

thanks

Sten and Johnnie for their patience and Oscar-winning interest in the book.

Susan and Jessica for their mothering and unstinting patience.

Michael for being a Rottweiler.

Rachel for feeding Michael large bones.

Charlotte for taking years off us.

Maria for smoothing and soothing stressed tresses.

Robin for not compromising the quality of his pictures in spite of the speed in which they were taken.

Antonia for taking care of the clothes.

Kelly for taking care of Susannah's children.

Al for letting his birds go.

Ed and Lizzie for wheels and deals.

Tracey for not listening to a word of our clothing advice.

Vickie for What Not To Wear.